Flint
1890–1960

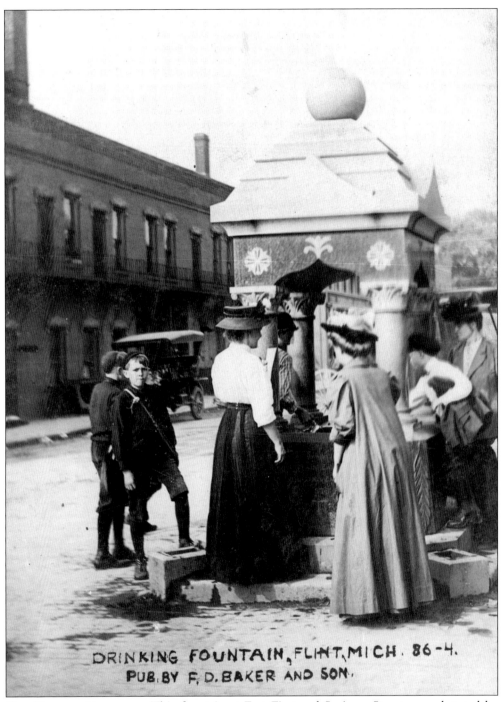

DRINKING FOUNTAIN, FLINT, MICH. 86-4.
PUB. BY F. D. BAKER AND SON.

THE BARNEY FOUNTAIN. This fountain at East First and Saginaw Streets was donated by Marvin C. Barney, owner of Barney Granite & Marble Works, and connected to an artesian well that was put down *c.* 1873. The fountain was put in place around 1900, but by 1930 it was deemed a traffic hazard and was moved. It was restored in 1976 and placed in Hamilton Park, at King and Fifth Avenues. (Jack Donlan Collection.)

POSTCARD HISTORY SERIES

Flint

1890–1960

Genesee County Historical Society

ARCADIA

Published by Arcadia Publishing
Charleston SC, Chicago IL, Portsmouth NH, San Francisco, CA.

Printed in the United States of America

Library of Congress Catalog Card Number: 2004104150

For all general information contact Arcadia Publishing at:
Telephone 843-853-2070
Fax 843-853-0044
E-Mail sales@arcadiapublishing.com
For customer service and orders:
Toll-Free 1-888-313-2665

Visit us on the Internet at http://www.arcadiapublishing.com

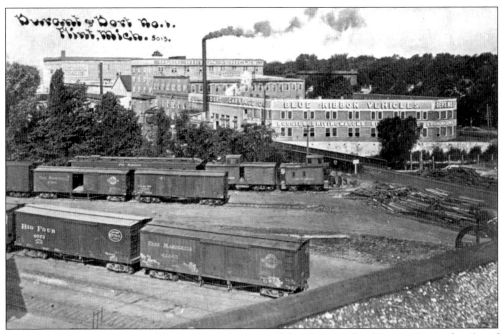

BLUE RIBBON VEHICLES. These were the top-of-the-line in the Durant-Dort family of carriages. The postcard is captioned "Durant-Dort No. 1" but it actually includes several factories that made up the Durant-Dort complex along West Water Street. Durant-Dort built light commercial trucks called the Best and the Flint *c.* 1910–1912, and then the complex became home to the Dort Motor Car and built the Dort car, named for J. Dallas Dort. (David White Collection.)

CONTENTS

Introduction 7

1. Downtown Memories 9

2. Leisure Time 29

3. The Vehicle City at Work 37

4. Places of Worship 53

5. Taking Care of Business 67

6. Kindergarten to College 83

7. Serving the Community 95

8. Living in Flint 107

9. Olla Podrida 119

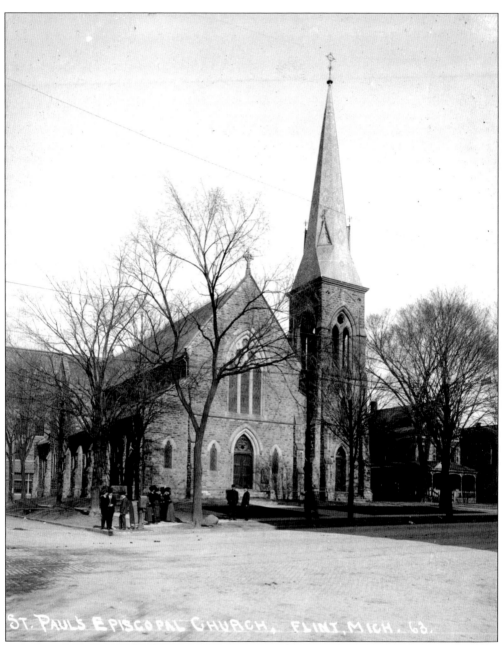

ST. PAUL EPISCOPAL. The first meetings of Episcopalians in Flint were in 1839, and the place of worship has always been within a couple blocks of the current structure at South Saginaw and Third Streets. This third building was first used for worship services on August 24, 1873. The Gothic Revival style structure was constructed of stone from John Sutton's quarry in Flushing; the stone was hauled in by river and over frozen winter roads. The cross at the top of the steeple was handwrought by William A. Paterson in his wagon and carriage shop nearby. The total cost of the church was $26,000. The attached parish house was built in 1917 along with the Five Sisters Chapel addition to the church. (Sloan Museum Collection.)

INTRODUCTION

This postcard book is a project of the Genesee County Historical Society, as a venture for Flint's sesquicentennial. Most of the cards in this book date from around the start of the 20th century to the early 1930s—the heyday of the penny postcard—and they illustrate many changes in the city's history. The earlier images show a time when pleasure boats cruised up and down the Flint River and docked near downtown, where carriage factories in and near downtown made Flint the leading producer of carriages, wagons, and other horse-drawn vehicles

Many of the downtown photos include the city's steel arches, which spanned Saginaw Street and held the downtown streetlights. The first arches were put up in 1899, and then two more were added in 1905, for the city's Golden Jubilee. One arch was capped with signs reading "Flint—Vehicle City" in honor of the carriage-makers' success.

The city got a new Carnegie library, a post office, and a county courthouse for the 1905 Golden Jubilee. The courthouse later burned, and the library and post office were both razed.

Even in the first three decades of the century, the city saw amazing changes; Flint grew from a small town into a center of the auto industry, home of General Motors. Its population exploded as workers streamed in to work in the huge industrial complexes—Buick in the north, AC Spark Plug in the east, Fisher Body to the south, and Chevrolet on the city's west side.

Many of these photos are documentary, showing how this building or that school or street looked in the old days. A few are playful, as when a photographer added images of airplanes or other airborne craft to some of his photos. Several of them are news photos, showing a flood, fire, or other incident.

Some are odd: who would think to make a postcard from a photo of a dairy wagon, a grocery store, or a railroad locomotive? We are glad they did, because the images are part of the story of Flint. The cards show a time when the city had several popular movie and stage theaters downtown, and two busy amusement parks. Streetcars and interurbans shared the streets with carriages, wagons, cars, bicycles, and trucks, and passenger trains made several stops daily in downtown Flint.

This book was researched and written by Robert Florine, past president of the historical society; Dale Ladd, past president of the Flint Genealogical Society; James Miller, *Flint Journal* reporter; and David White, past president of the historical society.

We are grateful to Guy A. Gaines and Louis Pesha, two of the most prolific of the postcard photographers, along with Arthur Crooks, F.D. Baker & Son, Ball & Wanek, Roy Gardner, Mr.

Ferguson, and the others who took these photos.

The cards are from the collections of the Sloan Museum, Robert Florine, Dale Ladd, David White, Leroy Cole, Jack Donlan, Wallace Eaton, Joseph Guerin, Debbie Propes, Jack Skaff, and John Straw. Research was done with materials at the *Flint Journal*, the Flint Public Library, Kettering University, and the Sloan Museum.

We call the last chapter "Olla Podrida" because it's a little piece of Flint publishing history: The *Wolverine Citizen*, an old Flint newspaper, used that phrase as a headline for miscellaneous small items.

One

DOWNTOWN MEMORIES

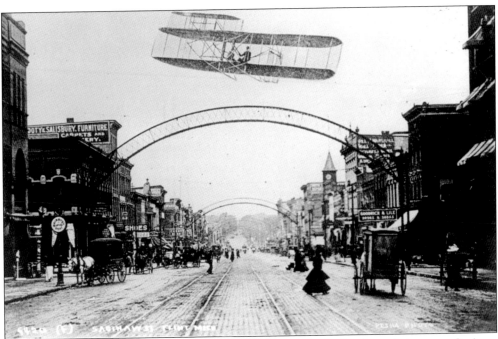

ORVILLE BUZZING FLINT? No, that's not one of the Wright Brothers flying over Saginaw Street. Postcard photographers in the early 20th century occasionally stuck an image of an early airplane or dirigible into other photos to liven them up. Maybe the camera didn't lie, but the photographer could fib a little when making a print. (Jack Donlan Collection.)

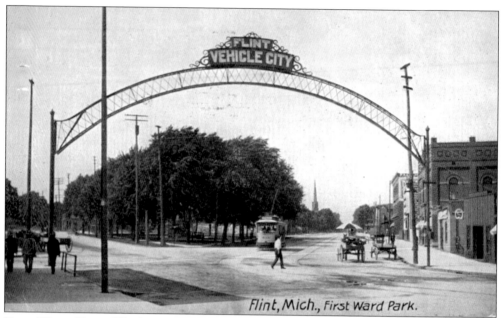

Flint, Mich., First Ward Park.

FIRST WARD PARK. Flint's carriage makers made the city the top producer of wagons, buggies, and other horse-drawn vehicles, earning it the title "Vehicle City." When the city celebrated its Golden Jubilee in 1905, two new arches were added to those already in place, and the one north of the Flint River carried the sign "Flint—Vehicle City." (Bob Florine Collection.)

BRYANT HOUSE. This hotel was built in the 1870s at Saginaw and Union Streets. It was reported in 1936 that the building would be torn down and a new commercial building would be built. Later it was discovered that the two upper floors had been removed, and the lower floors of the old hotel remodeled for retail use. The building was finally torn down almost 50 years after its "obituary" had been written, to make way for a parking lot for Water Street Pavilion. At the right is Hubbard Hardware, Flint's oldest continuing business, which has since relocated and is now known as Hubbard Industrial Supply. (Dale Ladd Collection.)

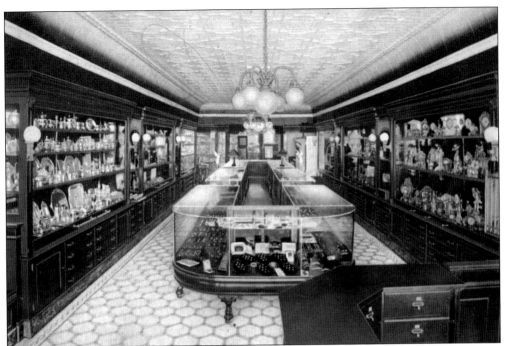

JEWELRY STORE OF WILLIAM E. FELLOWS. William E. Fellows was the son of Charles Fellows, founder of the *Flint Journal*. William was a watchmaker in 1894, and had a jewelry store for many years at 322 South Saginaw Street. He was a vice president and director of the Union Industrial Trust & Saving Bank. (Bob Florine Collection.)

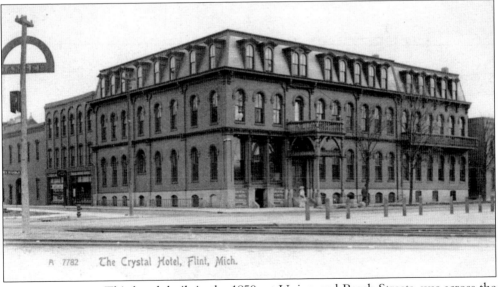

A 7782 The Crystal Hotel, Flint, Mich.

CRYSTAL HOTEL. This hotel, built in the 1850s at Union and Beach Streets, was across the street from the Pere Marquette Railroad station. It was originally called the Thayer Hotel but was renamed the Crystal Hotel when mirrors, prisms, and glass spangles were installed as decorations. It was popular for Sunday night suppers. The building was razed in 1933. (Bob Florine Collection.)

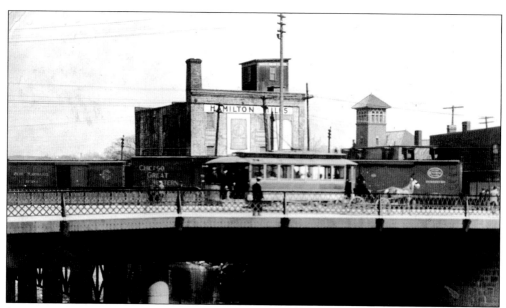

SAGINAW STREET BRIDGE. A streetcar shares the bridge with a horse-and-buggy, with the Pere Marquette railroad bridge behind them. The Hamilton Mill, which gave Hamilton Dam its name, was on the south bank of the river, approximately where the state office building was built. (Jack Donlan Collection.)

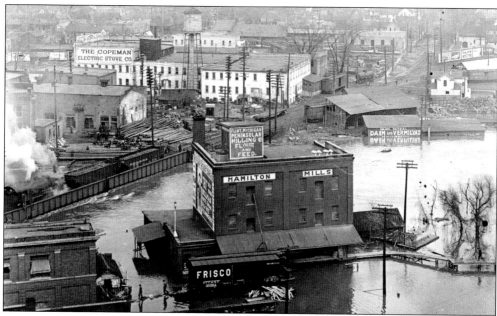

SPRING BRINGS FLOODS. Downtown Flint was split in half by a major flood in 1904. On the left side of the photo, a steam engine is pushing a loaded string of coal cars onto the railroad bridge over the Flint River. The railroads took this precaution during high water in an effort to keep the floods from floating the bridge off its foundation. Several downtown buildings were damaged by water and chunks of floating ice. Dynamite was used in an attempt to break up the ice dams. (Dale Ladd Collection.)

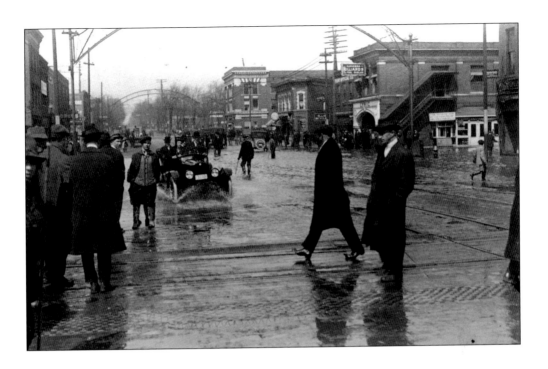

1916 FLOOD. At its peak, water was two feet deep south of the Flint River bridge, and one man told of catching a fish that was swimming between the rails on the tracks west of Saginaw Street. Water flowed through the front of some stores on the west side of Saginaw Street and right out the back. Old-timers told anyone who would listen about the "real" flood that happened "back in 1904." (Sloan Museum and Bob Florine Collection.)

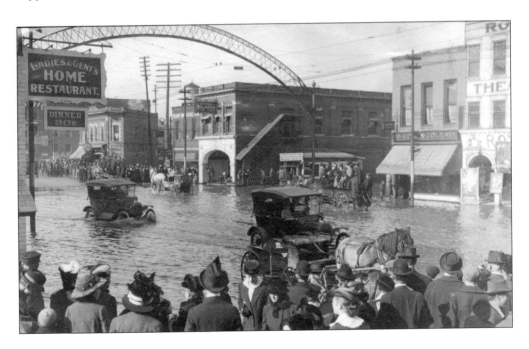

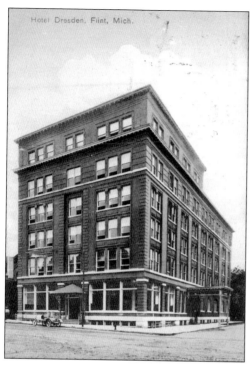

Hotel Dresden, Flint, Mich.

DRESDEN HOTEL. This card shows the hotel as a five and one-half story building. Another card, not shown in this book, has the hotel as a five-story building. The card on the bottom of the page, dated 1912, shows a six-story hotel. (Bob Florine Collection.)

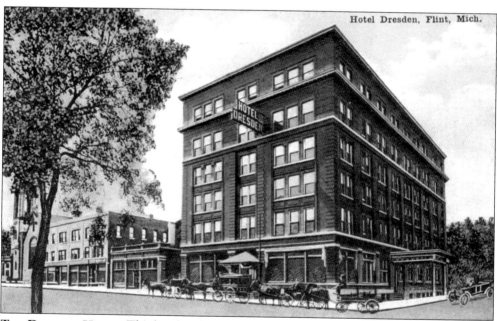

Hotel Dresden, Flint, Mich.

THE DRESDEN HOTEL. This hotel at the southwest corner of Third and South Saginaw streets opened in 1907. It was built by carriage and auto pioneer William A. Paterson. The hotel was named after the German city Dresden and was the leading hotel in Flint. Billy Durant and Benjamin Briscoe had a series of meetings there that led to the formation of General Motors. The name was later changed to Milner and then Adams before fire destroyed the building in 1963. (Dale Ladd Collection.)

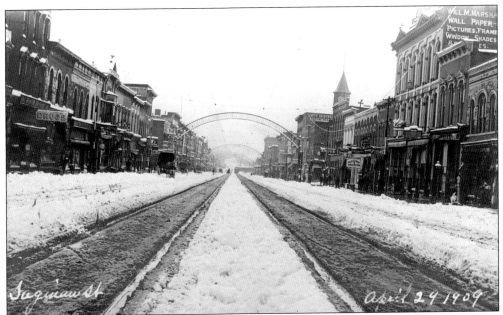

APRIL SNOW. A snowstorm on April 29, 1909, filled Saginaw Street, but the streetcars still got through. This photo was taken from near Second Street, looking north; the Electric Theater is on the right side, and the building with the tower is the Union Trust & Savings Bank. (Bob Florine Collection.)

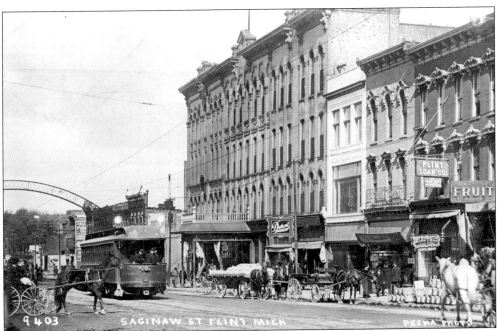

SAGINAW STREET. This street scene was photographed early in the 20th century; the Detroit Cash & Credit Co. was at 311 South Saginaw from about 1909 to about 1914, and the Electric Cigar Store was nearby during approximately the same period. The large building in the middle of the photo is the Bryant Hotel. (Leroy Cole Collection.)

FLINT VEHICLE FACTORIES MUTUAL BENEFIT ASSOCIATION. This association leased a building at Kearsley and Harrison in 1910. Club dues were 10¢ a week in addition to benefit dues. The building had a gym, bowling alleys, billiard, reading, and lounge rooms, but probably most important were the 29 showers, because at the time, many factory workers were living in shacks, tents, or railroad cars. By 1919, membership had reached 18,000, and a newspaper article said the building was "badly overcrowded." In 1922, the FVFMBA merged with the Industrial Fellowship League to create the Industrial Mutual Association—better known as the IMA. (Sloan Museum Collection.)

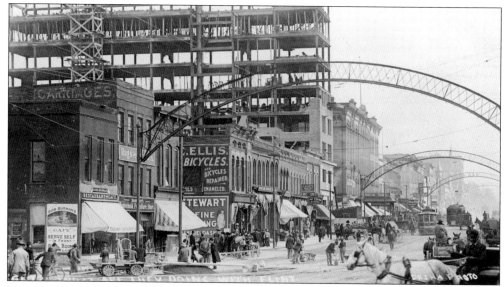

THE FLINT P. SMITH BUILDING. In this image, the building is under construction, which dates this card to 1910. Smith died while the building was under construction; his wife oversaw its completion and named it for him. It was one of the first buildings in Michigan to be built with structural steel, and was called "Flint's first skyscraper." It was later bought by dentist Erwin Sill and renamed the Sill Building. The Sill Building was razed in 1984. (Dale Ladd Collection.)

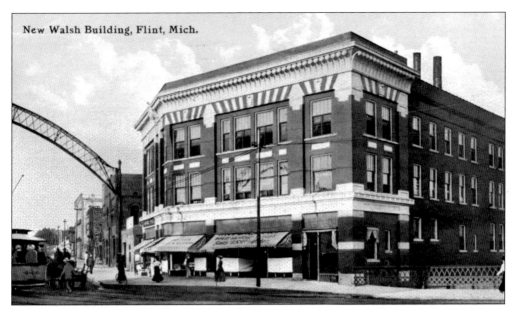

NEW WALSH BUILDING. The Walsh Building was built around 1910 at 310–316 North Saginaw, just north of the Flint River, by Joseph L. Walsh, who moved his livery business there in 1910. There is an ad for suits on the awning, so this photo may be from around 1913, when Nemath Shoes, Glasgow Tailor, and Frankforter Dry Goods occupied the building, along with the Harden & Welch saloon. The building was razed in 1971 to make way for Riverbank Park. (Leroy Cole Collection.)

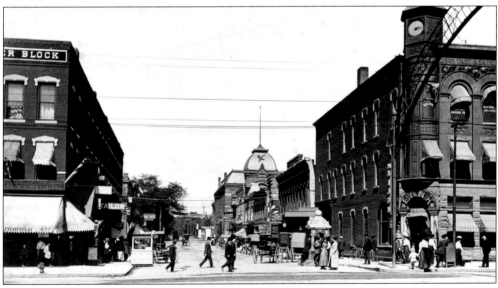

EAST FIRST STREET, FROM SAGINAW STREET. The building with the clock tower at the right is the former Union Trust & Savings Bank building, torn down in 1929 to make way for the Union Industrial Bank Building, now the Mott Foundation Building. The domed building at the right rear is Stone's Opera House, removed to make way for a new *Flint Journal* building. When this photo was taken, the *Journal*'s office was on East First Street, midway between Harrison and Saginaw streets. (Bob Florine Collection.)

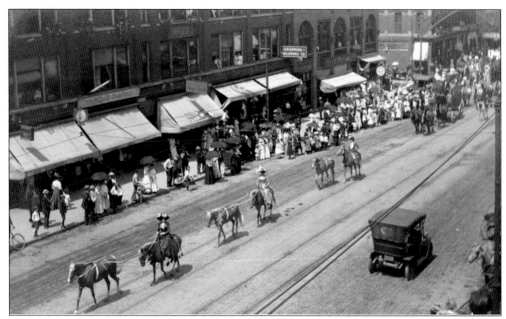

A Barnum and Bailey Circus Parade. This photo shows the parade going north on Saginaw Street *c.* 1910. A circus parade down the main street was common years ago as a way to drum up interest. (Sloan Museum Collection.)

Leather and Wood. This postcard was made of tooled leather, and shows downtown Flint with its arches and streetcar tracks in place. Postcards were also made of aluminum, and even wood. Some were "fold-out" cards with several pages. (Dale Ladd Collection.)

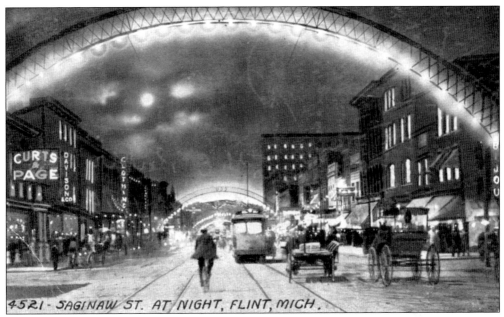

FLINT'S ARCHES. The arches were put up to support new streetlights; the arches of light made a dramatic effect at night. At Christmas, the white lights were replaced by red and green bulbs—something that traffic engineers won't permit on the replica arches because they are worried drivers won't see stoplights. The original arches were put up in 1899 and taken down in 1919. (Bob Florine Collection.)

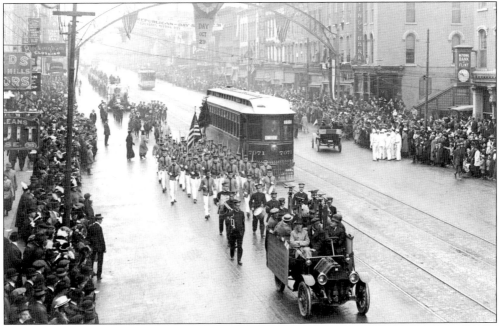

GOOD ROADS PARADE .This card probably shows a "Good Roads" parade that was held on Oct. 29, 1914. The day's events also included a football game, fire department exhibition, and fireworks. (Dale Ladd Collection.)

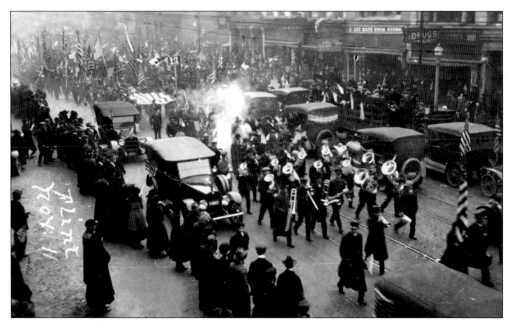

WORLD WAR I ENDS! There were two celebrations when news came that World War I had ended; the first was a spontaneous explosion of excitement after a false report of surrender on Nov. 7, when people piled onto trucks and cars, waved flags, and crowded the streets. It happened again on Nov. 11, when the war was really over. (Dale Ladd Collection.)

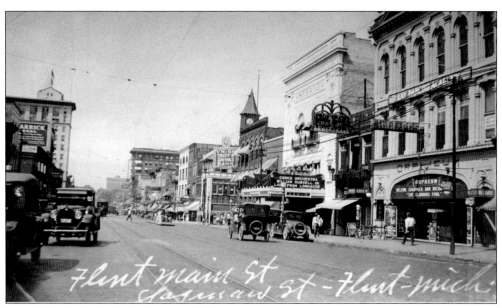

ORPHEUM & STRAND. This downtown view is probably from the early 1920s, when the Orpheum (right) and Strand Theaters operated close to one another. The Orpheum was torn down, and a five-story State Theater was built in its place in 1924. The State, which included a ballroom on its upper floors, was demolished in 1952 and replaced with Winkelman Bros. Apparel. (Debbie Propes Collection.)

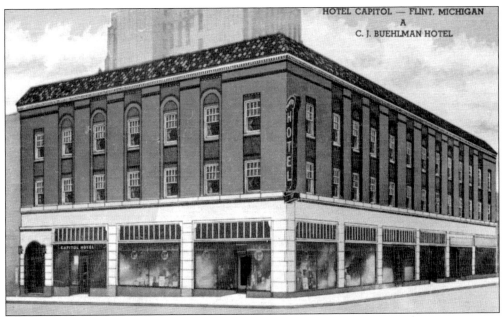

CAPITOL HOTEL. This three-story hotel was built in 1928 at the northwest corner of Second and Harrison Streets, opposite the Capitol Theatre, and on the site of the Dibble House. The card states "100 rooms at $1.75 to $3.00 with coffee shop." The Capitol was closed in 1980 for health and safety reasons. The site is now a parking lot. (Bob Florine Collection.)

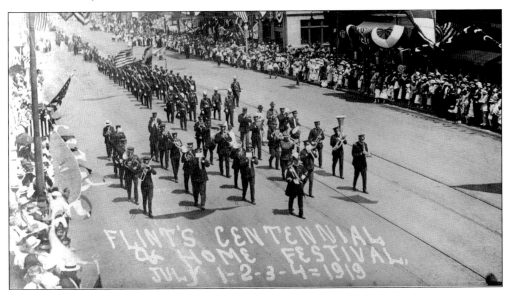

TWO CENTENNIALS. There's nothing like a party. Flint celebrated two centennials in the 20th century, but who cares about math? This was part of the parade for the first centennial celebration in 1919, 100 years after what was thought to be the date that trader Jacob Smith set up shop near the Flint River not far from the "Grand Traverse." The city's official centennial—100 years after Flint became a city—came in 1955, and it was an even bigger party, with all kinds of civic events and a visit from Chevrolet's favorite singer, Dinah Shore, and the country's vice president, Richard M. Nixon. (Sloan Museum Collection.)

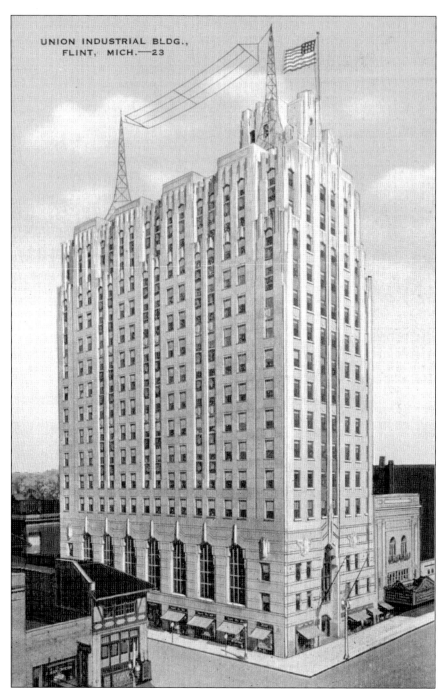

UNION INDUSTRIAL BLDG., FLINT, MICH.—23

UNION INDUSTRIAL BANK. This building was built in 1930 after news came out in 1929 that a senior vice president, two vice presidents, and other employees of the bank had been caught embezzling money to invest in stocks; an estimated $3.5 million was gone. The building went up quickly: hardwood pilings were driven for the foundation in January, work on finishing the interior of the building began in the summer, and the bank began operations there in December. The Mott Foundation got the building in 1944. (Bob Florine Collection.)

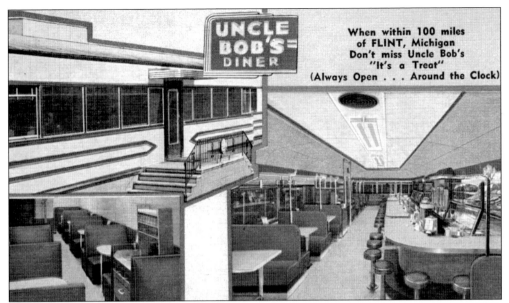

UNCLE BOB'S DINER. It looked like it might have been made from a railroad dining car, but it wasn't. The Harrison Street restaurant was put together from prefabricated sections in 1947. The diner was well-known for its food. It closed in 1973 and in 1987 it was disassembled and moved to the Rockford, Michigan area, where it serves as an artist's studio and gallery. (Jack Donlan Collection.)

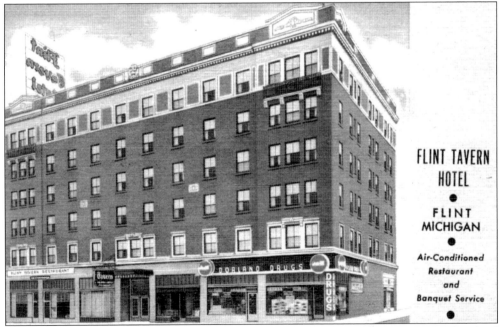

FLINT TAVERN. This 200-room fireproof hotel with an air-conditioned restaurant and cocktail lounge was opened in 1928 at the southwest corner of Detroit Street (now M.L. King) and Third Avenue. It closed as a hotel in 1958, but immediately re-opened as Marian Hall for the elderly. It is now operated by Odyssey House as a drug rehabilitation center. (Bob Florine Collection.)

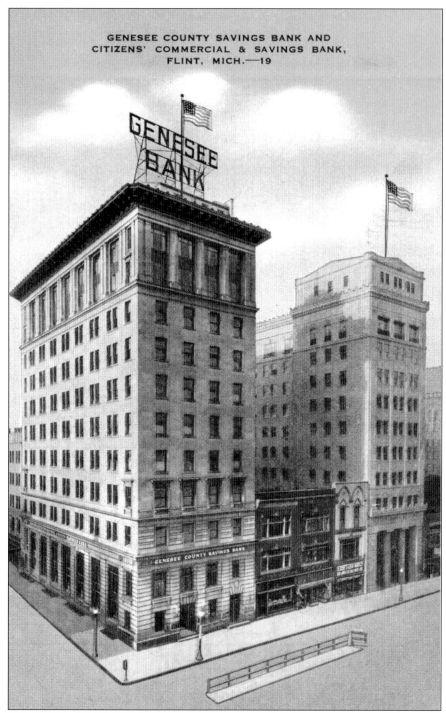

GENESEE COUNTY SAVINGS BANK AND CITIZENS' COMMERCIAL & SAVINGS BANK, FLINT, MICH.—19

GENESEE COUNTY SAVINGS BANK AND CITIZENS COMMERCIAL & SAVINGS BANK. These two banks got into a competition to see which one would build the tallest bank. Genesee Bank won the "building battle" when it built the Genesee Towers building. Genesee was acquired in a series of mergers, while Citizens remains independent. (Bob Florine Collection.)

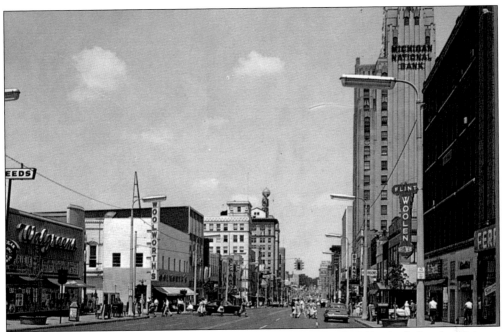

IT'S THE '60S. This view of downtown—probably from around 1960—includes the Citizens Bank Weather Ball in the skyline in the distance. The weather ball was installed in 1956. (John Straw Collection.)

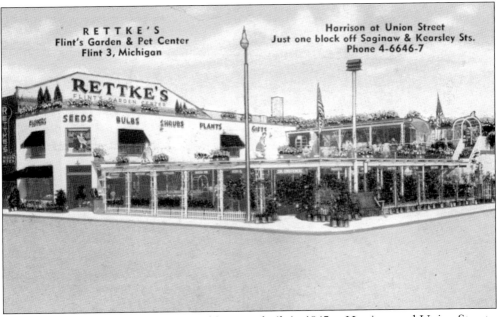

RETTKE'S GARDEN CENTER. This building was built in 1945 at Harrison and Union Streets. The store featured a "roof top garden" over part of it, and also added pets and pet supplies. The building was damaged by fire in 1965 and opened the next year as Smith-Bridgman's garden center. (Bob Florine Collection.)

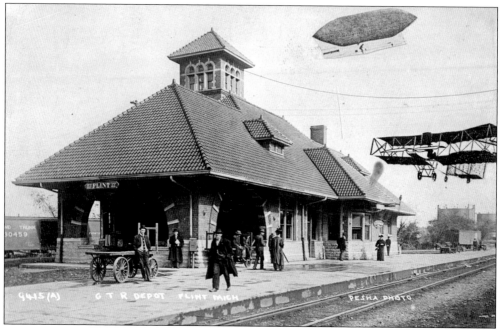

DETAILS ADDED. Photographer Louis Pesha added the dirigible and airplane to spice up this photo of the Grand Trunk Railroad passenger station. The station was built around 1903 and was dismantled in 1929. (Sloan Museum Collection.)

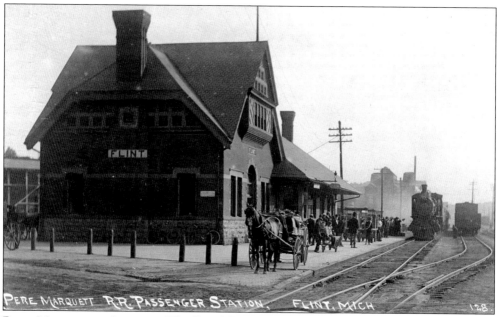

PERE MARQUETTE STATION. The Pere Marquette and Grand Trunk railroads had separate passenger stations in Flint, only a few blocks apart. The PM station, shown here, was at Beach and Union Streets while the Grand Trunk station was off Water and Harrison Streets. The PM station was razed in 1957. (Leroy Cole Collection.)

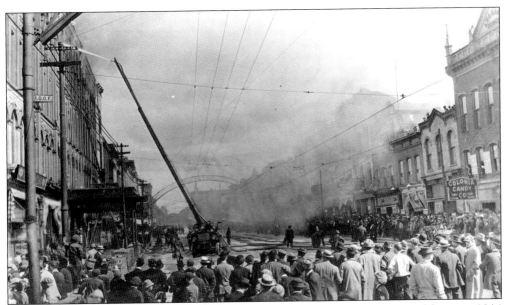

THE FLINT FIRE DEPT. Flint Fire Department had a remote-control aerial hose in 1914 when a fire struck the Bryant House; notice there is no firefighter aiming the spray. (Leroy Cole Collection.)

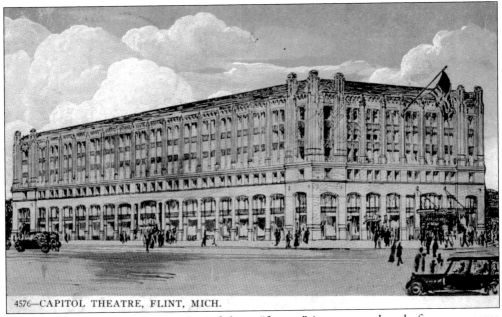

4576—CAPITOL THEATRE, FLINT, MICH.

CAPITOL THEATER. This is another of those "fantasy" images, produced after news came out in 1926 that a new theater would be built. This unbuilt version of the Capitol is bigger, but no more ornate, than the version that has graced Second Street since 1928. (Debbie Propes Collection.)

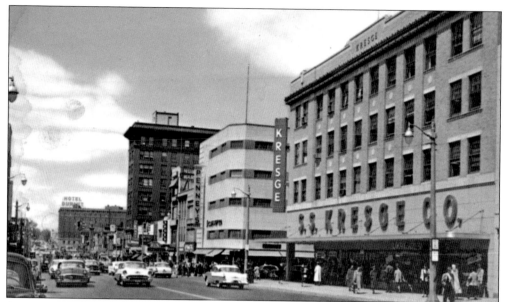

ALL GONE. The Kresge Co. announced a new store for downtown Flint in 1928, to replace a building known as the Fenton Block. For many years, Flint shoppers were treated to the smell of caramel corn as they went through the door at Kresge's. The store closed in 1977. McCrory's moved in for a few years, then the building was torn down in 1984 to make way for the Center City plaza, later known as Flint Festival Marketplace, and finally named Water Street Pavilion. The J.C. Penney's store (center), the Sill Building, and everything else on these blocks along Saginaw and Harrison Streets were razed. (John Straw Collection.)

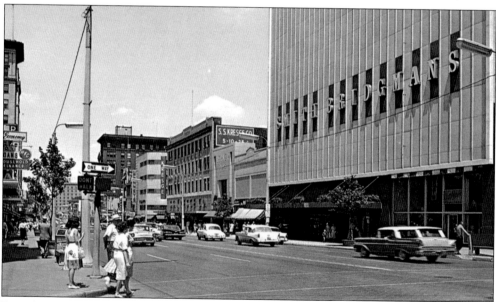

DOWNTOWN FLINT. This photo is from around 1960 when Smith-Bridgman's was one of the city's biggest and busiest stores. The store closed in 1980, and the building and others in the block were torn down in 1984 for parking for the Water Street Pavilion project. (Debbie Propes Collection.)

Two

LEISURE TIME

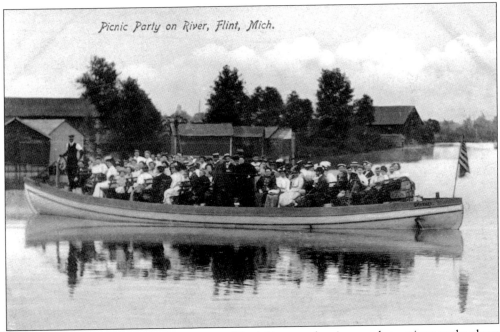

Picnic Party on River, Flint, Mich.

A PICNIC PARTY ON THE FLINT RIVER. Picnicking on the river, and at various parks along the river, was a very popular weekend and holiday activity. (Dale Ladd Collection.)

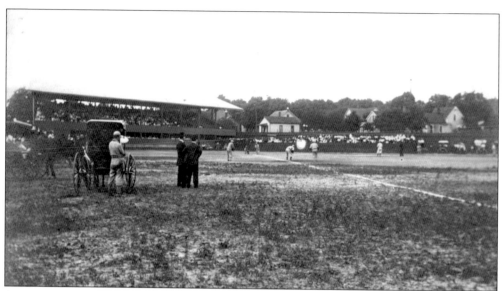

ATHLETIC PARK. A popular baseball park operated by the IMA was off Third Avenue near the IMA Auditorium. It was used from about 1900 to the 1950s. (Jack Donlan Collection.)

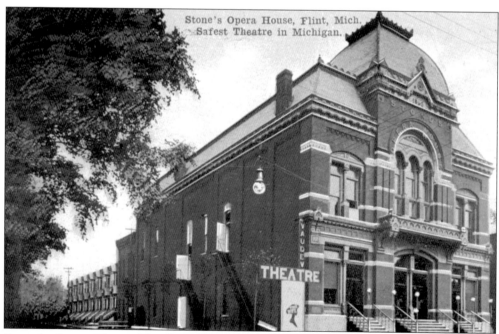

STONE'S OPERA HOUSE. The Opera House at East First and Harrison Streets, was one of the classier theaters in town. The theater was known as the Majestic Theater when it was torn down in 1924 and replaced with a new building for the *Flint Journal*. Theater owner, Oren Stone, had founded Flint Woolen Mills in 1867 and was the city's mayor in 1888. (Bob Florine Collection.)

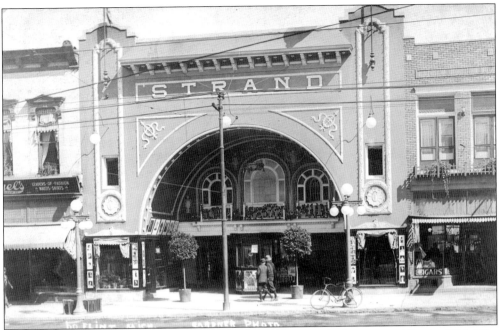

THE STRAND. This theater was one of at least eight theaters in downtown Flint in 1916. The theater was built in 1915 and closed in 1958. After closing, the management continued to operate the snack bar, selling popcorn, hot dogs, barbecue, and other snacks. The building was bought by the Mott Foundation and replaced with an office building.(Wally Eaton Collection.)

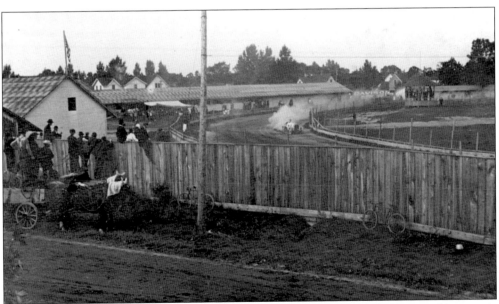

RACE TRACK. This may be a picture of early auto racing *c.* 1910 at the county fairgrounds between Lapeer Road and Avon Street, south of Sixth Street. Note that some people are getting a free show by standing on a horse-drawn wagon or by looking through a 'knothole' in the wood fence. (Jack Donlan Collection.)

31

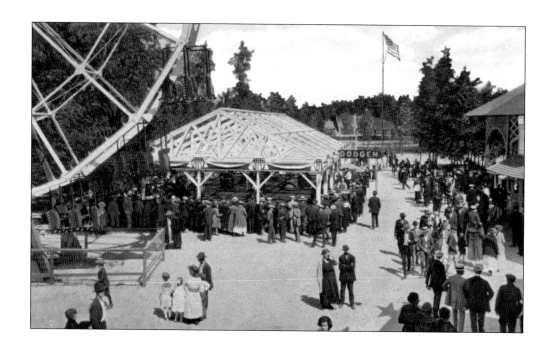

FLINT PARK. Flint Park was operated by E.E. Berger from 1920 until his death in 1944. His widow, Flora, and daughter, Mrs. Lewis H. Firestone, ran it until the 1960s. This was a very popular private amusement park. (Dale Ladd Collection.)

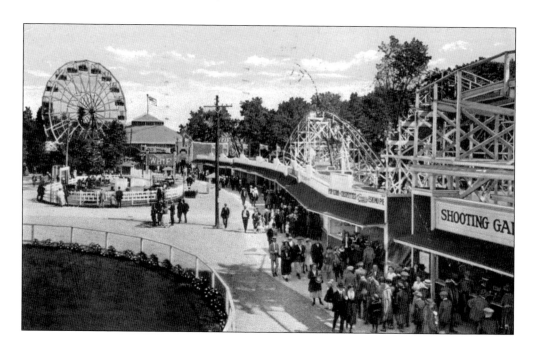

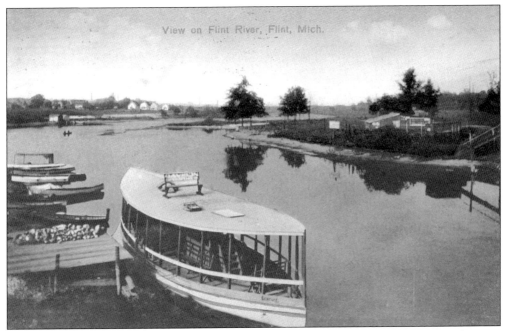

BOATS ON THE FLINT RIVER. This is a picture of the *Genesee*, a popular excursion boat on the Flint River. Recreation enjoyed long ago is receiving new consideration in redevelopment plans for the city today. (Dale Ladd Collection.)

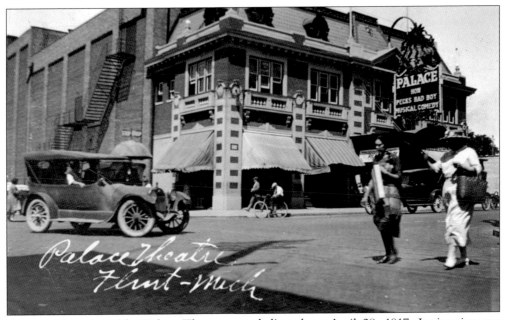

PALACE THEATER. The Palace Theater was dedicated on April 28, 1917. Its interior was fashioned to represent a Roman garden with twinkling lights in the ceiling to simulate the night sky. The Palace was equipped for stage shows as well as movies. It showed its last movie, *Foxy Brown*, on Jan. 22, 1976. The building was torn down in 1977. (Debbie Propes Collection.)

33

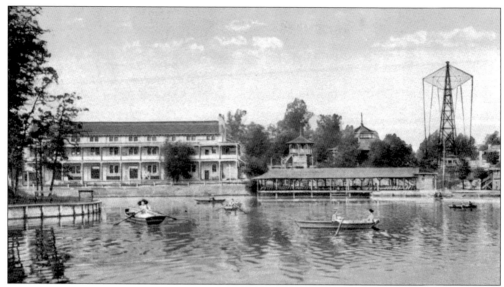

LAKESIDE PARK. Prior to 1900 Lakeside Park was known as Peer's Grove, by 1900 this recreation area was known as Lakeside Park. It was one of the most popular amusement spots around Flint. Its fireworks on the Fourth of July, dances, concerts, and rides were famous. Balloon ascensions and parachute drops were added attractions. The park boasted one of the longest roller coasters in Michigan. The city acquired the property in 1936 and leveled most of the attractions. In 1942 it was renamed after George L. McKinley, a former mayor. (Bob Florine Collection.)

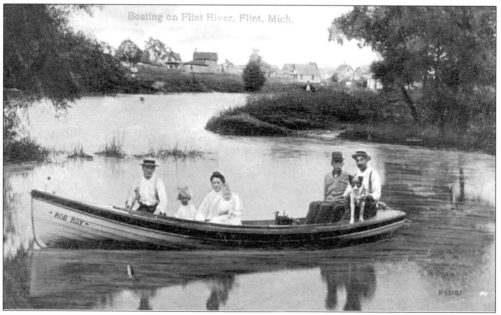

PLEASURE BOATING ON THE FLINT RIVER. Pleasure boating was a very popular pastime on Sunday afternoons. The flood of 1916 ended this era, as most of the boats and docking were swept away. Smith Brothers were one of the biggest operators of pleasure craft. (Jack Donlan Collection.)

PAVILION AT KEARSLEY PARK. The Kearsley Park pavilion and pool were built in the early 1920s. The pool was demolished in the 1980s. The pavilion still stands and is used as a neighborhood gathering place. The park is currently being renovated through a collaboration of the City of Flint, Mott Community College, and other non-profit organizations. (Bob Florine Collection.)

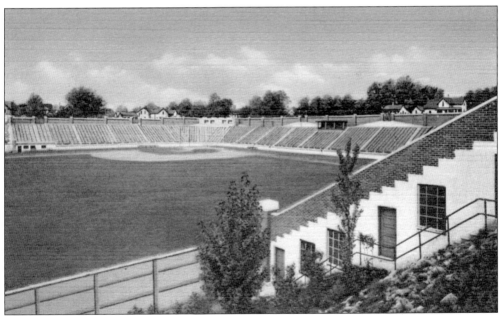

ATWOOD STADIUM. In 1927 the property for Atwood Stadium was donated by Edwin Atwood, a two-term mayor, to the city of Flint in memory of his father, William Atwood, a former mayor. Originally given as a park, the stadium was dedicated in 1929. The stadium was created by filling in the north channel of the Flint River at Moon Island. (Jack Skaff Collection.)

WILLSON PARK. This park was originally the garden around the home of Governor Henry Crapo and Dr. James Willson. The park was given to the city by the Willson family and is now part of the University of Michigan-Flint grounds. (Bob Florine Collection.)

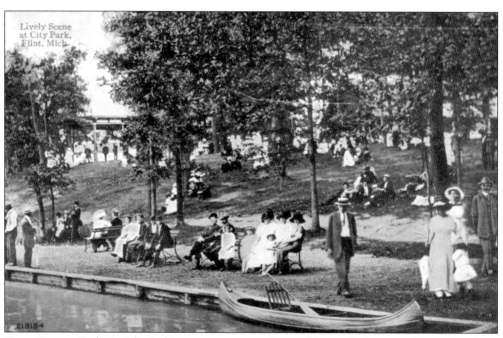

CITY PARK. Early in Flint's history, many people would spend time on the weekends at various city parks. Those located on a river or lake were very popular. This park is thought to be Lakeside Park on Thread Lake. (Dale Ladd Collection.)

Three

THE VEHICLE CITY
AT WORK

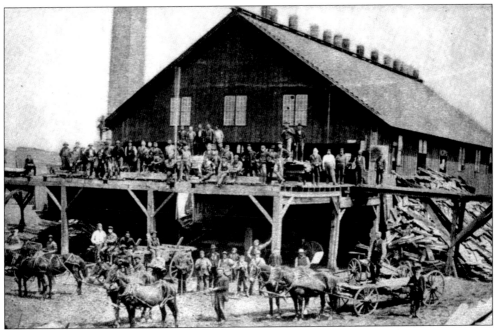

CRAPO MILL. Flint's first big industry was logging. One of the biggest operations was run by Henry H. Crapo, later governor of Michigan and grandfather of William C. Durant, founder of General Motors. This sawmill was on the site later occupied by the Randall Lumber Co. and IMA Auditorium, and now by the White Building of the University of Michigan-Flint. (Bob Florine Collection.)

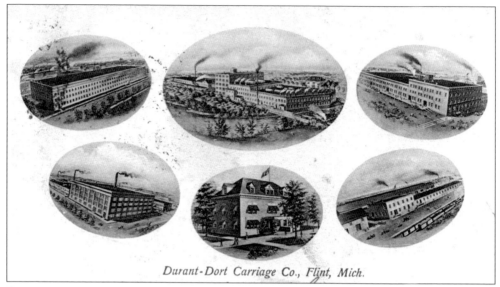

Durant-Dort Carriage Co., Flint, Mich.

DURANT-DORT CARRIAGE CO. For Flint, Durant-Dort was the "General Motors" of the carriage industry. The illustration at top center is the main complex along Water Street, with the office building below. The rest of the illustrations show various factories. Durant-Dort subsidiaries included Diamond Buggy Co., Webster Vehicle Co., Victoria Vehicle Co., Durant-Dort Axle Co., Flint Gear & Top, Flint Varnish Works, and others. (Bob Florine Collection.)

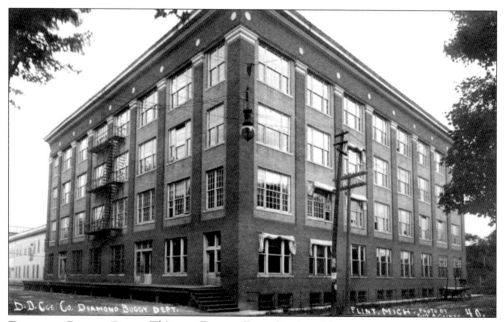

DIAMOND BUGGY DEPT. This was Durant-Dort Carriage No. 4, at Water Street and Grand Traverse. The Diamond buggy was a low-to-medium priced line of buggies—the "Chevrolet" of the Durant-Dort product line. The wood-frame building was destroyed in an arson fire in 1987. (Leroy Cole Collection.)

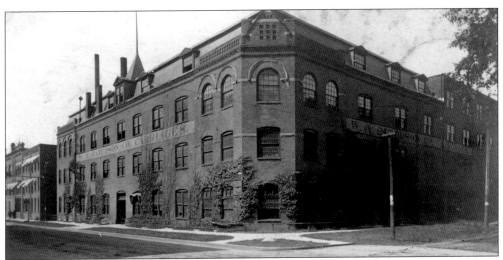

PATERSON CARRIAGE CO. Starting in 1869, W.A. Paterson was the first of Flint's "Big Three" carriage makers. Paterson Carriage Co. was followed by the Flint Wagon Works and Durant-Dort Carriage Co. When all three were going strong, Flint became the leading producer of carriages, wagons, and other horse-drawn vehicles. This was Paterson's first large factory, built around 1888. A larger building was built across Third Street, and the company began manufacturing the Paterson automobile there in 1908. Car production ended around 1923. (David White Collection.)

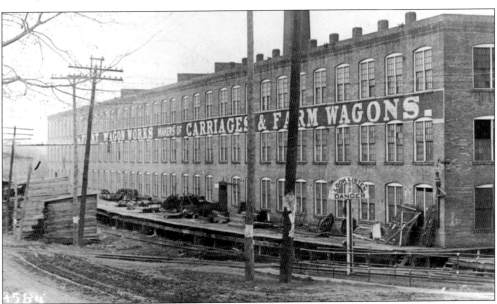

FLINT WAGON WORKS. The second of Flint's leading carriage-makers was an outgrowth of Begole, Fox & Co., one of Flint's early lumber companies. James H. Whiting, secretary and general manager, is given credit for suggesting that the lumber firm start making wagons. This building was on West Kearsley Street, and when the directors of the Wagon Works agreed to buy the Buick Motor Co. and move it to Flint in 1903, they built a building for the engine-maker nearby. Chevrolet moved into the former Wagon Works factories, and the complex that became known as Chevrolet Manufacturing grew up around them. (David White Collection.)

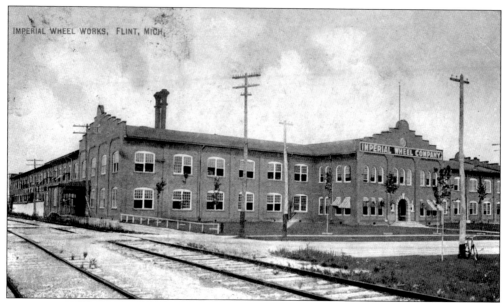

IMPERIAL WHEEL WORKS. This business was located in Jackson when William C. Durant began buying up all the auto companies and suppliers he could find for the new General Motors. He moved Imperial Wheel to Flint, where it was located in this building on Hamilton Avenue near the railroad crossing. The building was later bought by Chevrolet and leased to the Mason Motor Car Co., then Buick bought it. The building was razed for a Buick expansion in 1936. (Dale Ladd Collection.)

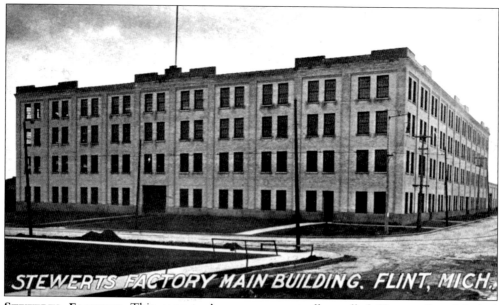

STEWERTS FACTORY. This company's name was actually spelled "Stewart," and it had factories in several locations. It built carriage bodies for the carriage makers including Paterson, Durant-Dort, and Flint Wagon Works. Then, when the auto industry arrived, Stewart began making auto bodies, too—for Cadillac, Chevrolet, Oakland, and Peerless—but its biggest customer was probably the nearby Buick factory. (Dale Ladd Collection.)

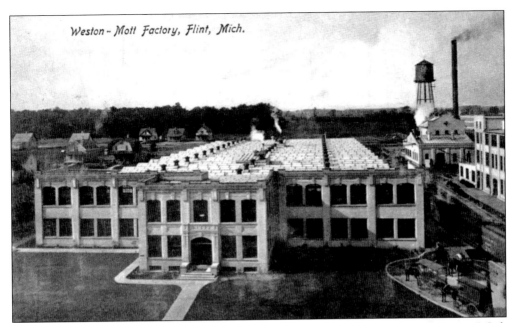

Weston-Mott Factory, Flint, Mich.

WESTON-MOTT FACTORY. This early view of the Weston-Mott factory shows a "sparse" Oak Park neighborhood on the left, no factories to the north, and part of Buick to the right. (Bob Florine Collection.)

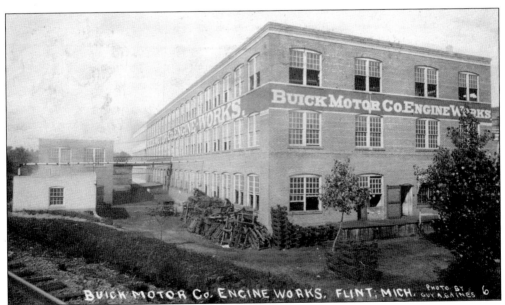

BUICK MOTOR Co. ENGINE WORKS, FLINT, MICH. PHOTO BY GUY A. GAINES 6

BUICK MOTOR CO. ENGINE WORKS. The Buick Motor Co. Engine Works factory was built on West Kearsley Street, across from the Flint Wagon Works factories, as a one-story building in 1903, when Buick only made engines, not cars. The first production Buicks were built here in 1904. (Bob Florine Collection.)

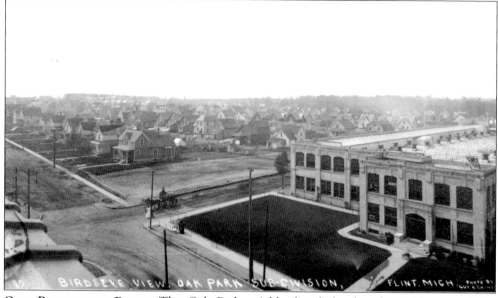

OAK PARK FROM BUICK. The Oak Park neighborhood developed quickly around the Buick factory in the first 10 years of the 20th century. To encourage a good neighborhood, the Durant-Dort Carriage Co., led by J. Dallas Dort, donated land for Oak Park Methodist Church, North Baptist Church, Dort School and playground. (David White Collection.)

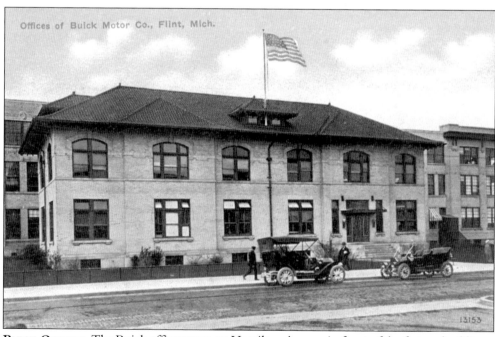

BUICK OFFICES. The Buick offices were on Hamilton Avenue in front of the factory buildings. The company quickly became one of the nation's leading automakers, and in 1908, William C. Durant used Buick as the foundation when he created a new corporation known as General Motors. (Bob Florine Collection.)

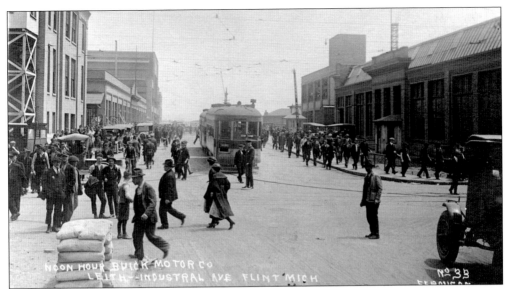

NOON HOUR AT BUICK. This was a busy place and a popular time for photographers to visit. This photo was taken at Leith and Industrial Avenue and while most of the people in the photo were too preoccupied to pay much attention to Ferguson, the photographer, a few men on the left side posed congenially—one with his arm around his pal's shoulder. (David White Collection.)

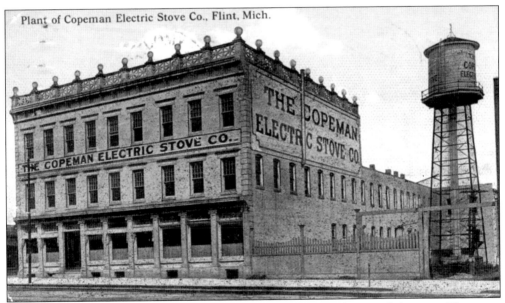

COPEMAN STOVE. This business was on Saginaw Street and Second Avenue. The stove company was organized in 1911, and its initial stockholders included Fred Aldrich and J. Dallas Dort of the Durant-Dort Carriage Co.; banker, A.G. Bishop, and Dr. James C. Willson. Inventor Lloyd Copeman was the grandfather of singer Linda Ronstadt and held more than 650 patents. The stove company was reorganized in 1914, then sold in 1917. The Copeman electric stove had timers to turn it on at a specific time, and shut it off after cooking for a set period. (Dale Ladd Collection.)

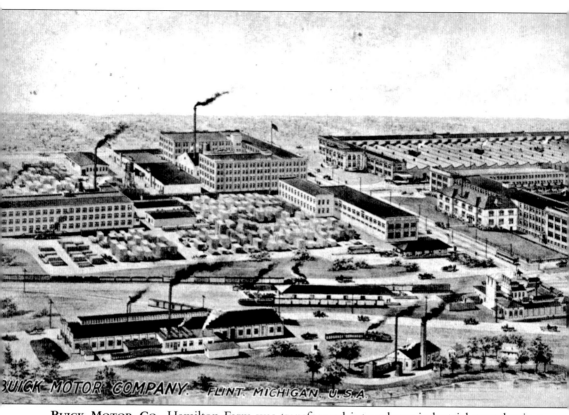

BUICK MOTOR COMPANY. FLINT MICHIGAN. U.S.A.

BUICK MOTOR CO. Hamilton Farm was transformed into a huge industrial complex in a fairly short period of time. Some carriage industry suppliers, including Flint Varnish Works, Durant-Dort Axle Works, and Stewart Body Co., were already along Hamilton Avenue when

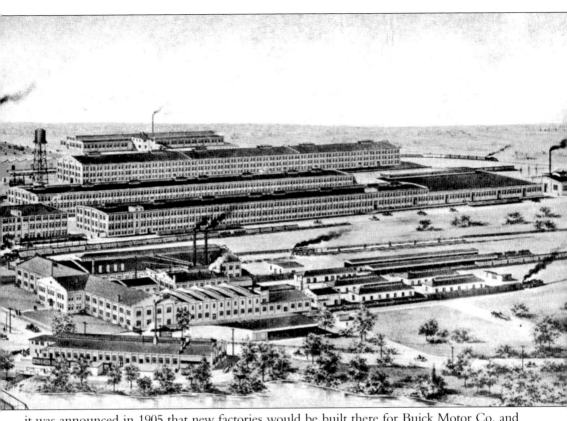

it was announced in 1905 that new factories would be built there for Buick Motor Co. and Weston-Mott Axle Co. By 1910 the area looked like this. (Jack Donlan Collection.)

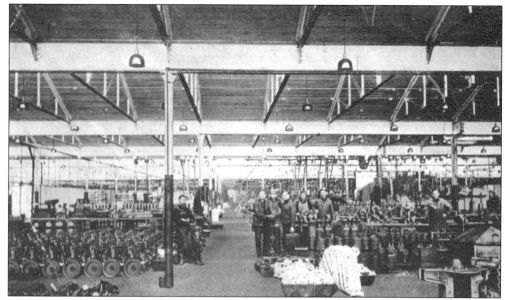

FACTORY 11. This Buick factory was a big plant for its time and was probably the first factory built by General Motors. It was built in 1909, the year after William C. Durant created General Motors and while he was still putting the conglomerate together. The factory built its last part on February 28, 2004. (Dale Ladd Collection.)

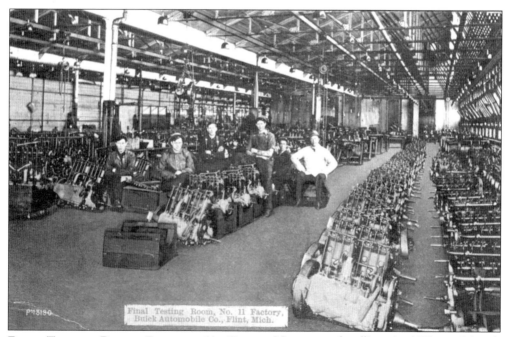

FINAL TESTING ROOM, FACTORY 11, BUICK. Newspaper headlines in 1909 proclaimed, "General Motors Will Locate $1,000,000 Engine Plant in North End of City of Flint." From 1911 to 1954, the factory produced all of the automobile engines for Buick. (Dale Ladd Collection.)

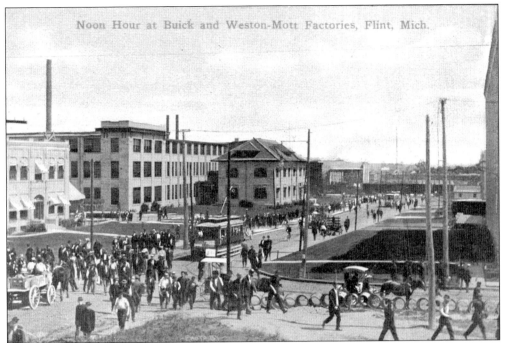

NOON HOUR AT BUICK AND WESTON-MOTT FACTORIES. There are carriages, wagons, a bicycle, and a streetcar in this *c.* 1909 photo of a busy Hamilton Avenue, but only one automobile. That's the front of a Stewart Body Co. factory at the extreme right. (Bob Florine Collection.)

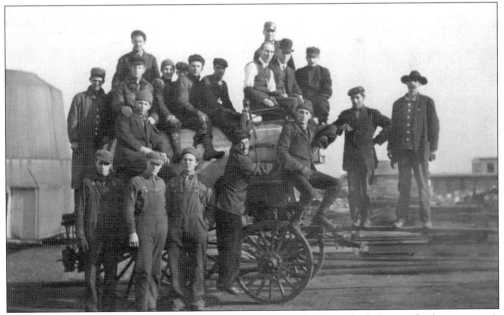

LOTS O' HELP. The driver of this wagon—whichever one he was—had plenty of volunteers to sit on this wagon when the photographer stopped by the Buick site. (Sloan Museum Collection.)

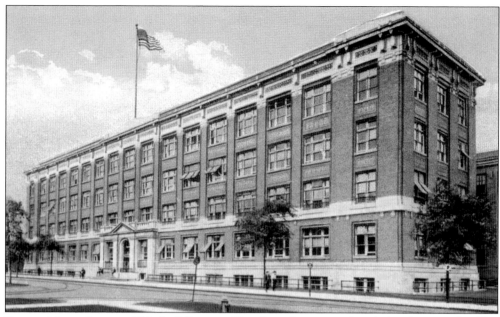

BUICK MAIN OFFICE. This building on Hamilton Avenue replaced the first Buick office building. It was torn down in 1968 after a new office was built at Hamilton and Industrial Avenues. Buick stopped making cars in Flint in 1998 and moved its headquarters to Detroit in 1999. Demolition of factory buildings began in 2001; all of the former Buick factory buildings south of Leith Street, and some to the north, have been razed. (Bob Florine Collection.)

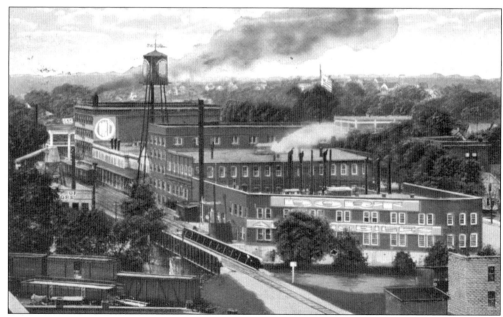

DORT MOTOR CAR COMPANY. The Durant-Dort Carriage Company factories switched to making the Dort Automobile in 1915. Production ended in 1924 shortly before the sudden death of J. Dallas Dort on the golf course. (Bob Florine Collection.)

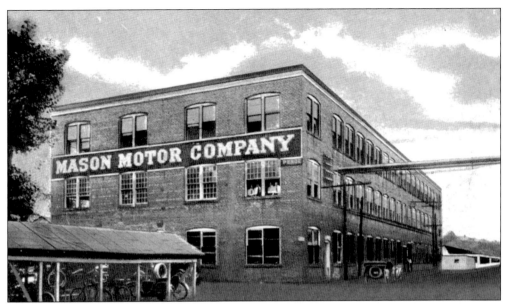

MASON MOTOR CO. This company was formed in 1911 to build engines for Chevrolet Motor Car Co., which also was formed that year. Mason was first located in one of the former Flint Wagon Works factories, then moved into this three-story brick building off West Kearsley Street that was built in 1903 as a one-story building, the first Buick factory. (Dale Ladd Collection.)

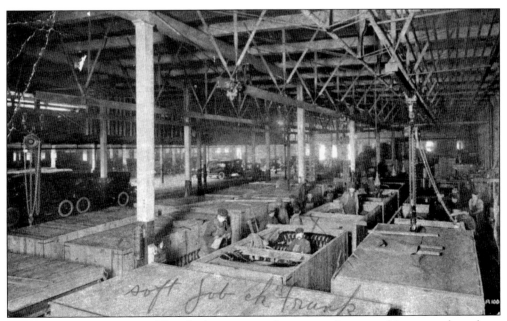

"SOFT JOB, EH FRANK." That is the message that was written on this postcard, perhaps referring to the worker seated in the topless touring car being crated up for shipping. As early as 1914 Buicks were exported from Flint to foreign nations. (Bob Florine Collection.)

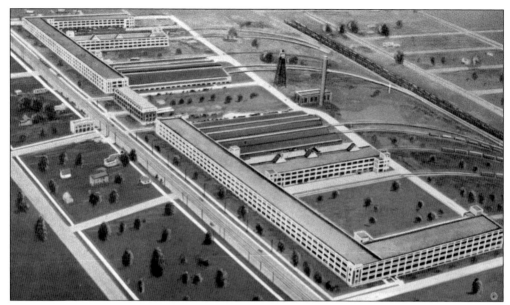

FLINT MOTOR CO. The factories along South Saginaw Street, between Hemphill and Atherton roads, were built for the Flint Motor Co. of Durant Motors. These factories built the Flint Six automobile from 1923 to 1926. The buildings were bought by GM for Fisher Body in 1926, and for many years the site was known as Fisher Body No. 1. It was one of two main sites for the 1936–1937 Sit-Down Strike that led to General Motors' recognition of the UAW. The main factories were demolished starting in 1988, and the site was renovated to become the Great Lakes Technology Center. (Bob Florine Collection.)

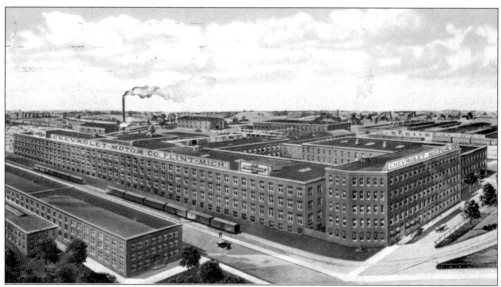

CHEVROLET MOTOR CO. This is an artist's impression of how Flint Wagon Works looked after Chevrolet took over the complex. The buildings are a little longer and a little taller than in real life. Kearsley Street is a little wider in this drawing, and the railroad cars look like toys. The building at left was built as a one-story factory for Buick in 1903; upper floors were later added and the factory was used by Mason Motor Co., then Chevrolet. (Dale Ladd Collection.)

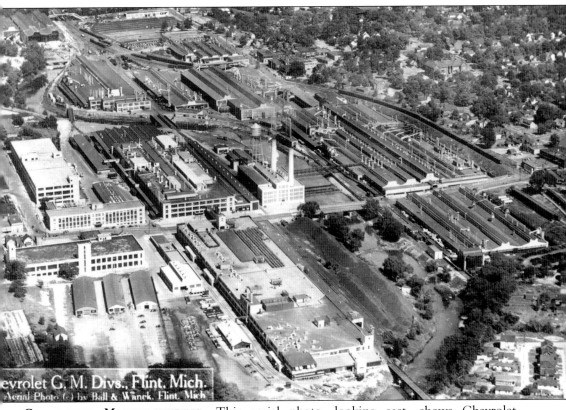

CHEVROLET MANUFACTURING. This aerial photo, looking east, shows Chevrolet Manufacturing at its peak, when it was one of four huge manufacturing complexes in Flint: Buick in the north, Chevrolet on the west side, Fisher Body in the south, and AC Spark Plug on the east. All but one of the buildings in this photo north of the river have been razed. (Dale Ladd Collection.)

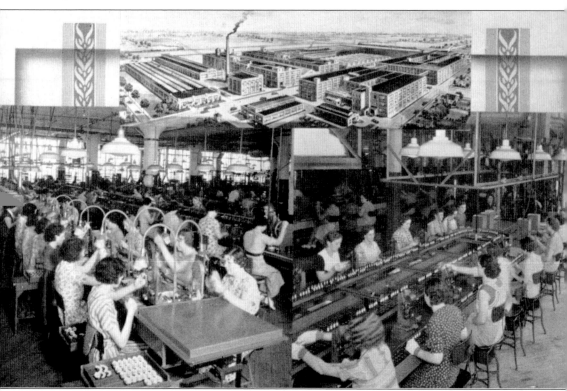

WOMEN AT WORK. The concept of women working in factories might have been a new phenomena for much of the country in World War II—made famous by "Rosie the Riveter"—but as this and other photos show, it was nothing new in Flint. AC Spark Plug hired many women workers from its earliest start in 1908. Other factories also had women in the manufacturing processes, not just in offices. (Bob Florine Collection.)

Four

Places of Worship

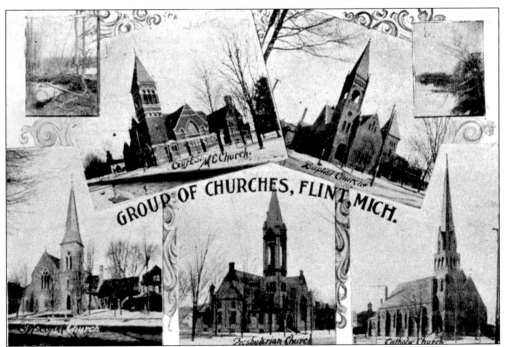

Church Group. This card is unusual because it is aluminum. A note on the address side says, "This card must be sent under cover only. Available as fourth class matter under ruling of the Postmaster General." The churches, clockwise from upper right, the Baptist, Catholic, Presbyterian, Episcopal and Court St. M.E., were all built before 1900. This card dates to *c.* 1905. (Wallace Eaton Collection.)

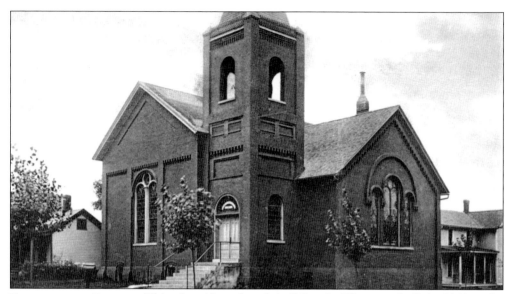

EVANGELICAL CHURCH. This, the oldest church building in Flint, was built in 1868 at the southwest corner of Second and Asylum Streets for $5,200. Originally housing the Evangelical Church with services conducted in German, it merged with other denominations and moved to a new site as a United Methodist church. It is now a Baptist church. Several structural changes have been made, including the addition of a basement and a tower in 1899. The steeple was later removed. (Bob Florine Collection.)

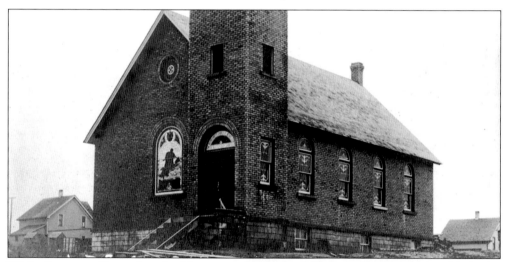

LDS CHURCH. Even though this postcard has the initials LDS, it truly is RLDS, the Reorganized Church of the Latter Day Saints. It was built at 529 East Newall Street for $4,500 including the lot. Without moving, the address became 529 East Hamilton Avenue through a renaming of the street. The basement was used for services in 1910 before construction was finished in 1911. A key architectural feature was a stained glass window built by an artist from Saginaw for $75. In 1973, the congregation moved to a new location. Since the new owners of the building did not want the stained glass window, it was installed at the new location at a cost of $4,000. Recently the denomination name was changed to Community of Christ. (Wallace Eaton Collection.)

COURT STREET METHODIST. Court Street Methodist can claim to be the oldest church society in Flint, starting in 1834. Most of its life has been on the current site at West Court and Church Streets. A frame building constructed in 1844 burned to the ground in 1861, and was replaced. The 1861 structure was replaced with a brick one in 1888. That building burned in 1892 and was replaced by the current structure in 1894, when it was then valued at $55,000. The 1861 and 1888 cornerstone ceremonies coincided with those of Garland Street Methodist. (Sloan Museum Collection.)

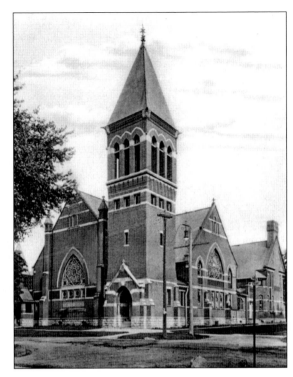

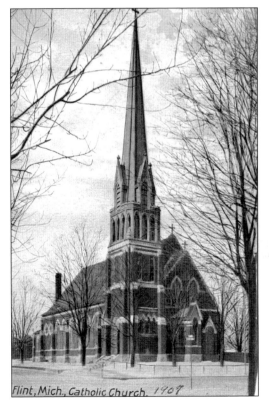

Flint, Mich., Catholic Church. 1907

ST. MICHAEL CATHOLIC. St. Michael Roman Catholic Church was organized in 1843. The building, completed in 1883 at the northwest corner of North Saginaw Street and Fifth Avenue, replaced a frame structure built of "finest pine" in 1848. This brick and stone building with a tall tower cost $30,000. A statute of St. Michael the Archangel was placed in a lofty niche at the front of the church. This building was replaced in 1964. (Sloan Museum Collection.)

55

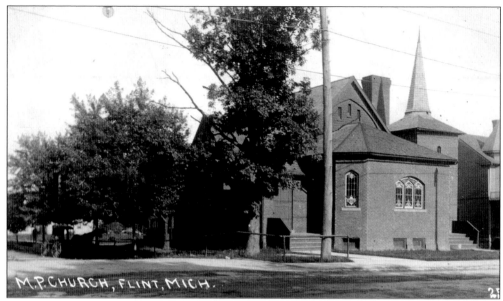

METHODIST PROTESTANT. This Methodist Protestant church was located at the southeast corner of North Saginaw and Elizabeth Streets. It was dedicated in 1901 and was used until 1932. It was torn down and the location eventually became a site for used car lots. (Sloan Museum Collection.)

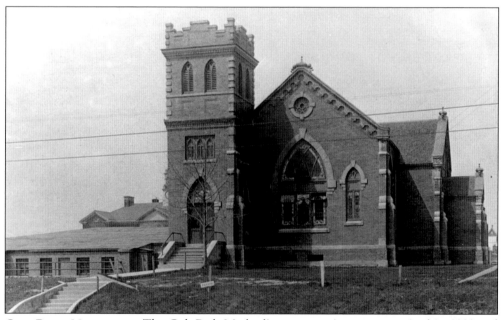

OAK PARK METHODIST. The Oak Park Methodist congregation was organized in 1909 and held its first services in a tent at the location of this building, which was at North Saginaw and Newall Streets. The basement was used for services until the building was erected in 1916. The facility had an approved system of lighting and an acousticon, or telephone for the deaf. The property for the building was donated by the Durant-Dort Carriage Co. The congregation formally dissolved in 2002. The building still stands. (Sloan Museum Collection.)

GARLAND STREET METHODIST. This congregation began in 1861 as the result of the fire that burned Court Street Methodist church on the south side of the Flint River. When the Court Street church had to be rebuilt in 1861, the Methodists north of the river wanted a facility more convenient to their neighborhood. On July 20, 1888, the cornerstone for the church's second building (shown on the card) was laid, the same date that the Court Street Church did the same for its new building. The church was located at the southeast corner of Garland Street and Second Avenue. In 1924, the name "Garland Street" was changed to "Central." The building was torn down shortly after the congregation moved to a new location in 1958. (Sloan Museum Collection.)

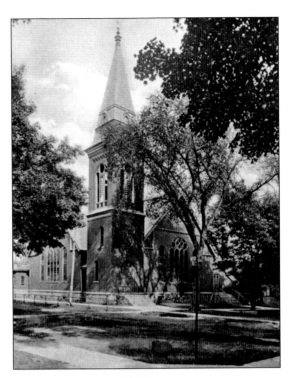

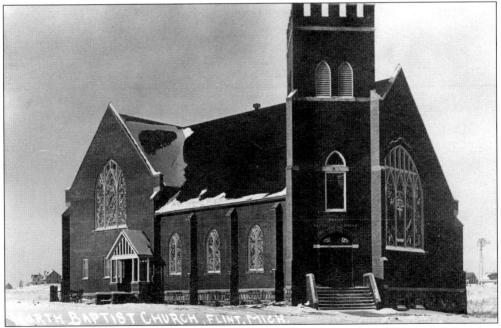

NORTH BAPTIST. This church began as a mission of the First Baptist. This red brick building was located at the northwest corner of Witherbee and North Saginaw Streets, a site which was donated by the Durant-Dort Carriage Co. The building was completed in 1910 and was remodeled in 1958. The congregation moved to a new location in 1998, however, this building is still in use as a church. (Sloan Museum Collection.)

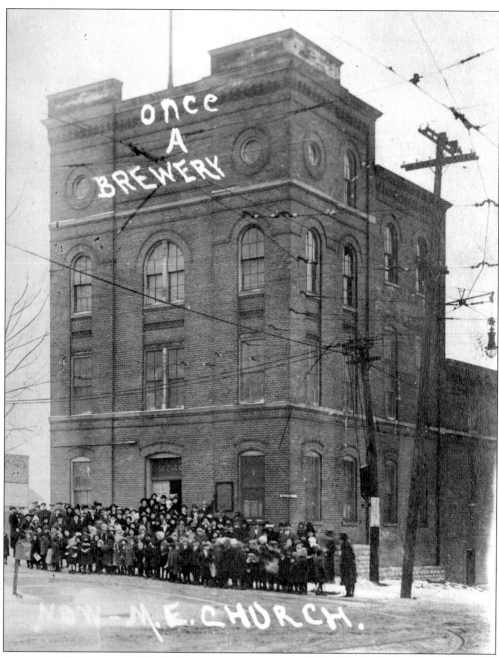

LAKEVIEW METHODIST. This building was built in 1899, and was used as the Flint Brewery. When Genesee County voted to become dry in 1915, a group of churchmen had an idea: "What better way to show the victory of religion over drinking than to convert a brewery into a church?" Lakeview Methodist Episcopal Church remained at that location for about five years until the congregation left to construct a smaller church building nearby. After that time, the building again became a brewery, then the office for a trucking company, warehouse, electric motor repair shop, welding shop, and a casket and woodworking shop. The building burned, and what remained was razed in 1992. (Sloan Museum Collection.)

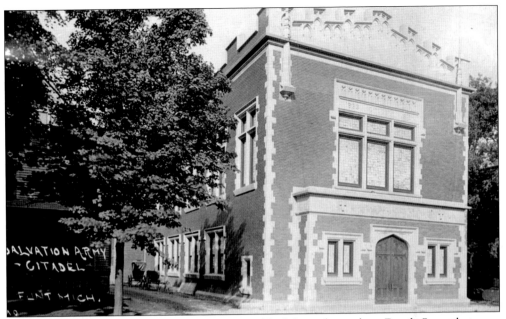

SALVATION ARMY. The Flint Salvation Army Citadel was located on Beach Street between Kearsley and First Street. It was dedicated in 1910 and is still part of the Salvation Army. An additional facility on Kearsley Street was erected in 1964. The army has been active in its band performances and nurturing to the needy in the area. (Sloan Museum Collection.)

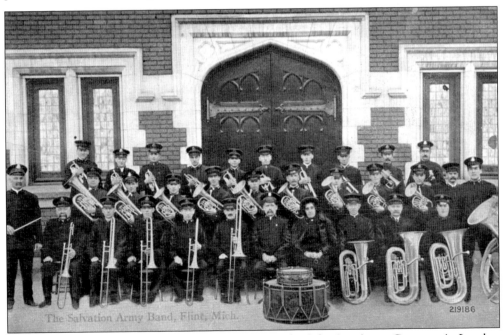

SALVATION ARMY BAND. This band was present at the Salvation Army Congress in London in 1914 and won high acclaims. It was sponsored by J. Dallas Dort, president of Durant-Dort Carriage Co. The card shows the band in front of the Flint City Hall, and the inscription on the drum reads, "Blood of Fire—The Salvation Army." (Bob Florine Collection.)

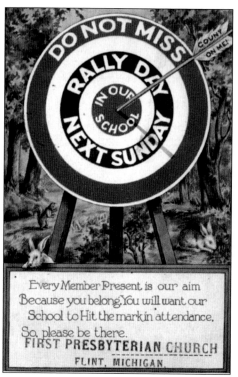

RALLY DAY. This undated Rally Day card was sent by First Presbyterian Church to encourage attendance at Sunday School. The reverse reads, "Come—Bring others with you." (Bob Florine Collection.)

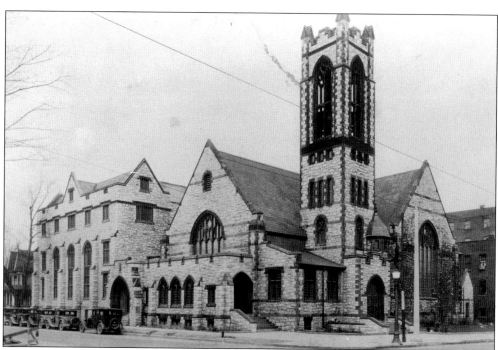

FIRST PRESBYTERIAN. The First Presbyterian church house was added in 1929. Note that the church tower no longer has a steeple. Additional facilities, conforming in style with the rest of the building, were added in 1987. (Sloan Museum Collection.)

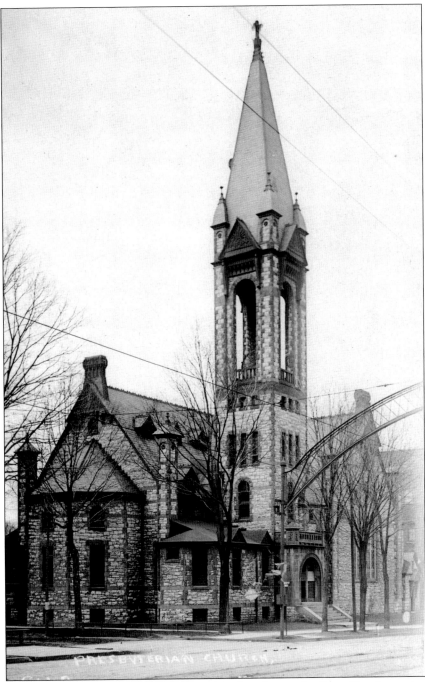

First Presbyterian. As the name implies, this church was the first of its denomination in Flint, and was officially formed in 1841. Its facilities have always been in downtown Flint. This structure was built in 1885 of Ionia sandstone on the northwest corner of South Saginaw and Fourth Streets. Its architecture reflects Queen Anne and Gothic styles. The total cost was $46,000 and the auditorium seated 620 persons. The tower was capped with this tall steeple—but what happened to it? (Sloan Museum Collection.)

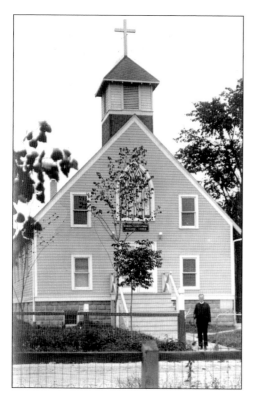

St. Joseph Hungarian. This church was built in 1921 at 1309 Hickory Street. It began with a survey of Roman and Greek Hungarian Catholics living in the East Side area near the Buick factory. Seven lots were purchased for $4,550. The parish originally had about 200 Hungarian families and another 100 families of other mid-European descent. Plans for a Catholic school were halted as residents began moving to other parts of the Flint area. By 1974, the neighborhood was claimed by urban renewal. (Sloan Museum Collection.)

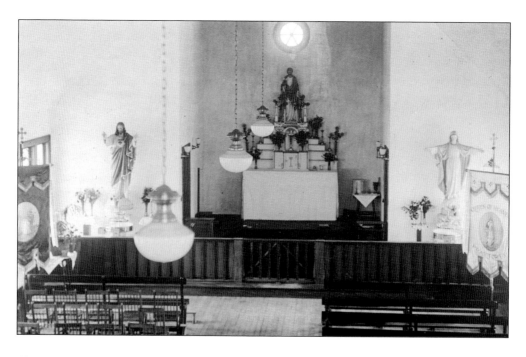

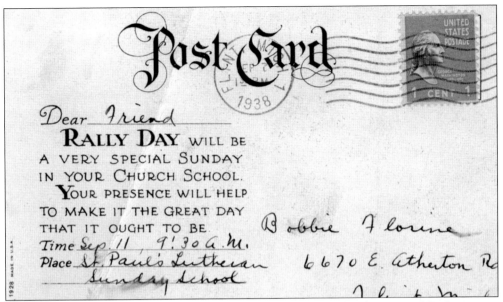

RALLY DAY. This postcard celebrating Rally Day for Sunday School at St. Paul Lutheran was sent to Bobbie Florine in 1938. (Bob Florine Collection.)

THE Corner Stone of the new St. Paul's Evangelical Lutheran Church, being built at the corner of Saginaw and Mary Sts., will be laid Sunday, Nov. 11 at 3:00 o'clock eastern time.

THE SPEAKERS WILL BE

Rev. Rud. Meyer, of Detroit, Chairman of the Church Extension Board; Rev. H. Grueber, of Saginaw, President of the Walther League; and Rev. F. Hertwig, of Detroit, Secretary of the Board of Home Missions. The Immanuel Lutheran band of Bay City will furnish the music. "Everybody come!"

Cordially yours,

Building Committee

Rev. Theodore Andres
Chairman

George Hollmann
Secretary

Hubbard Waller
Treasurer

Henry Meida
George Norwood
Edward Uhl
Edward Nedel
William Krueger

ST. PAUL LUTHERAN. The St. Paul Lutheran Church's second home was at North Saginaw and Mary Streets. It was dedicated in 1918 and had seating for 350 people. A parsonage was located on the west end of the property. The youth group of that time purchased two 10-foot-tall stained glass windows depicting Christ by the Von Geritchen Art Glass Company for installation in the chancel. The church built an adjacent school in 1940 and remained at that location until 1960, when an 880 seat sanctuary was built on new property. The building was demolished in 1960 when the Saginaw Street property was purchased by the Flint Public Schools. The Saginaw Street cornerstone and its contents are on display at this new address. (Wallace Eaton Collection.)

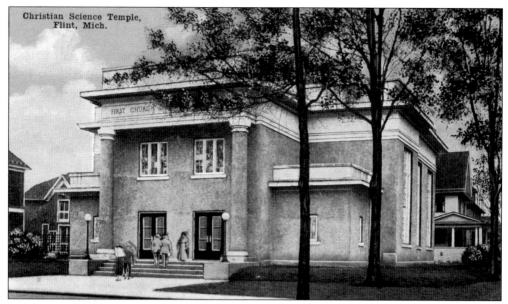

CHRISTIAN SCIENTIST. The first Christian Science service in Flint was held in 1897. After meeting in several locations, the Buckingham house at the southeast corner of Harrison and Court Streets was purchased. Nearly all of the structure was torn down and the edifice shown was erected in 1917. In May of 1988, the structure was demolished and a new church building was erected on the same site. (Sloan Museum Collection.)

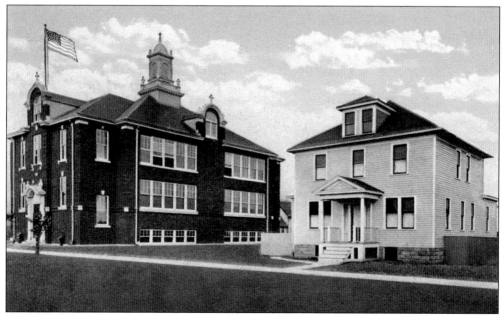

ALL SAINTS SCHOOL AND HOME. All Saints School and Home opened in 1913 at the intersection of Industrial and Maine. The high school operated until 1954 and the elementary school until 1957. The property was bought by General Motors for expansion in 1957 and the congregation moved to Pierson Road. (Jack Donlan Collection.)

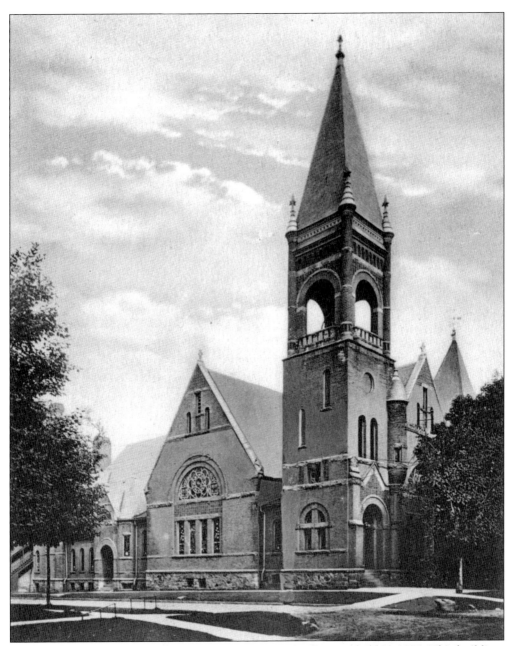

FIRST BAPTIST CHURCH. The first Baptist meeting in Flint was held in 1855. This building, the Baptists' second, was located at the southeast corner of Beach and Second streets. This "beautiful and commodious structure"—a credit to themselves and the city—was erected in 1890. Chinese brothers who were members of the early church contributed a pair of oriental windows for the church. The building was torn down in 1952 shortly after the congregation moved to a new site. (Sloan Museum Collection.)

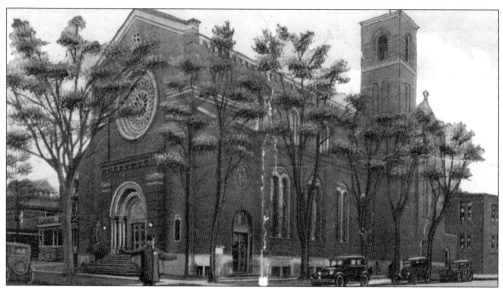

St. Matthew Catholic. The cornerstone of this building was laid in 1919 at the southwest corner of Beach and Third Streets. The City of Flint bought the previous facilities at the northeast corner of Beach and Third Streets for use as a police station. The style of this building is Romanesque. The building is 162 feet long and was built of red brown brick and sandstone, with a roof of red tile. The location of the bell tower at the rear of the building was unusual. The school building behind the church dates from 1920. All the buildings shown on the card are still in use. (Sloan Museum Collection.)

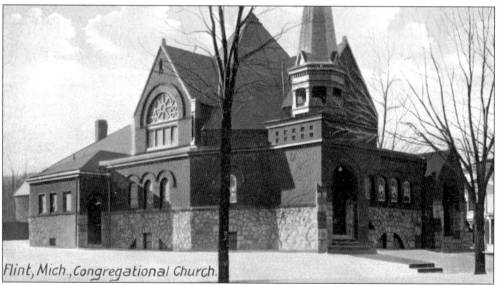

Flint, Mich., Congregational Church.

Congregational Church. The Congregational organization dates back to 1867 as an outgrowth of the Presbyterian Church. This building at 215 West First Street (between Beach and Church Streets) was dedicated free of debt in 1901. A fire destroyed the building in 1927. It was rebuilt by 1930 and later sold to the Flint Institute of Arts, which used it until the late 1950s. The building was then torn down to provide parking for the nearby telephone company workers. (Sloan Museum Collection.)

Five

TAKING CARE OF BUSINESS

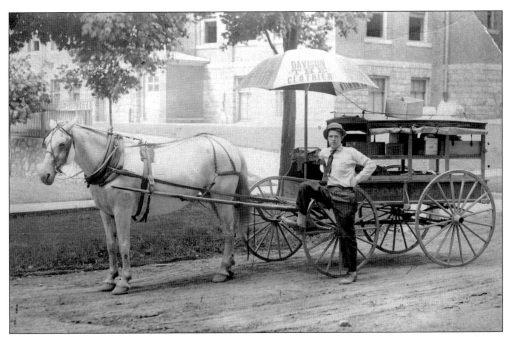

DELIVERY WAGON. The umbrella has the name "Davison the Clothier" on it, but the umbrella could have been a means of advertising, and the wagon may have been a general delivery wagon. Matthew Davison, Flint mayor in 1885, had a clothing store on Saginaw Street downtown from 1870 to 1883. Then his son, Arthur M. Davison, had a store at the same location, opening in 1899. Arthur M. Davison stayed in business downtown for more than 50 years, and died in 1958. (Sloan Museum Collection.)

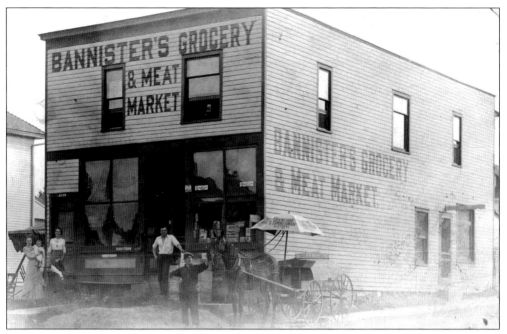

BANNISTER'S GROCERY. This store was at 1231 Lyon Street around 1910. The wagon bears a signboard reading "J.L. Dafoe," who operated a grocery store at that address in 1912. At that time there were many small "mom & pop" grocery stores serving the city's neighborhoods. (Sloan Museum Collection.)

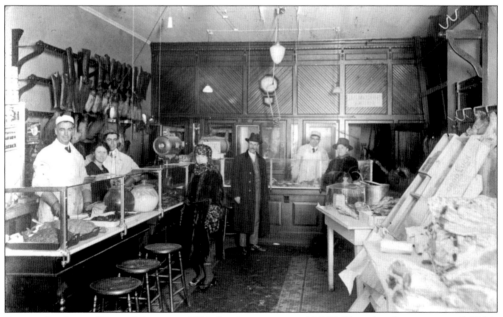

PEOPLE'S CASH MEAT MARKET. This business was at 124 E. Kearsley Street around 1916. There are slabs of meat—bacon, perhaps—hanging on the rack behind the counter men. (David White Collection.)

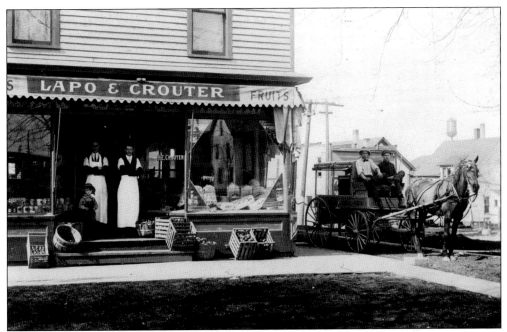

LAPO & CROUTER GROCERY. The Lapo & Crouter grocery store was at 755 Harriet Street around 1914. There are baskets and boxes of produce out front and ads for Carnation milk in the windows. The store had its own delivery wagon. (Sloan Museum Collection.)

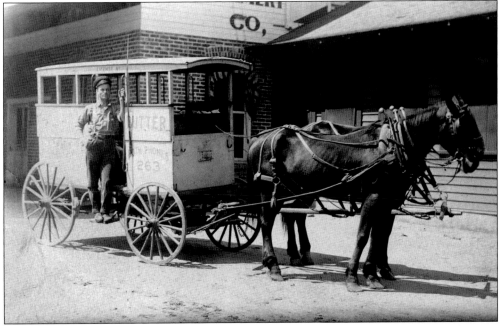

CREAMERY WAGON. The company is not identified, but the 1915 City Directory lists 12 "Dairymen and Milk Dealers" in the City of Flint, including the Blake, Freeman, and Flint Dairy companies. The horses often knew the routes as well as the drivers, and would know when to stop for a delivery. (Sloan Museum Collection.)

CARNATIONS. BOILEAU COPYRIGHT 1906

Our Annual Calendar

We hope the past season has been as prosperous for you as it has been for us. The quality of our service and goods has added many new names to our list. To show our appreciation of your trade, we have secured a limited number of handsome calendars, the illustrations being reproduced from an original painting, the work being done by The Thos. D. Murphy Co., of Red Oak, Iowa. We would like to have one of these calendars in every home in the county, but the great expense prevents. To make sure that you receive one, will ask that you kindly bring this card to our office some time between December 15th and January 1st and exchange it for the calendar we are saving for you.

Thanking you for past favors and wishing you a happy and prosperous 1908, we are

Respectfully yours,
FLINT LUMBER COMPANY.
North End Smith St. Bridge,
Flint, Michigan.

THE THOS. D. MURPHY CO. RED OAK, IOWA U.S.A.

OUR ANNUAL CALENDAR. This card was sent to customers of Flint Lumber Co. late in 1907, encouraging them to come to the office to receive a 1908 calendar. Flint Lumber operated on Smith Street (now North Grand Traverse Street) just north of the river from 1903 to 1980. (Jack Donlan Collection.)

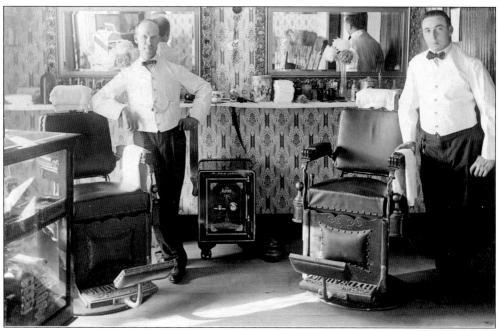

DESJARDIN BARBER SHOP. Alphonse Desjardins had a barbershop at 805 Harriet Street around 1910. This was the era when barbers wore white vests and bow ties, and kept a selection of cigars in a glass case. (Sloan Museum Collection.)

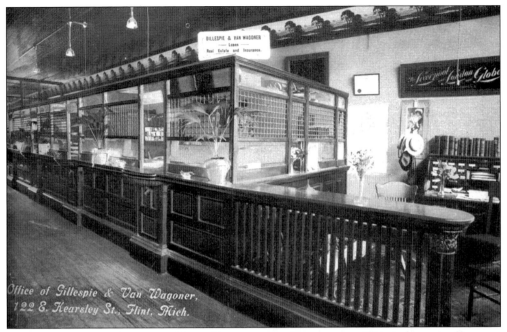

GILLESPIE & VAN WAGONER REAL ESTATE AND INSURANCE. This business' office was at 122 E. Kearsley Street in 1922. The firm also offered indemnity bonds and loans. (Bob Florine Collection.)

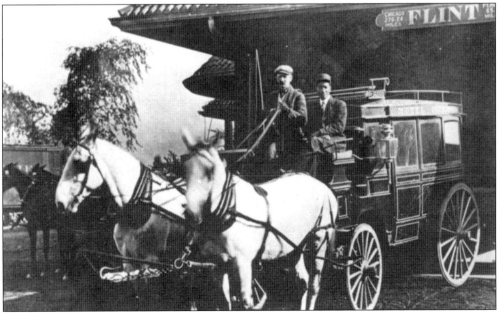

DRESDEN HOTEL BUS. The Dresden was a classy hotel on the southwest corner of Saginaw and Third Streets. It had its own enclosed carriage to carry passengers from the railroad stations to the hotel. (Dale Ladd Collection.)

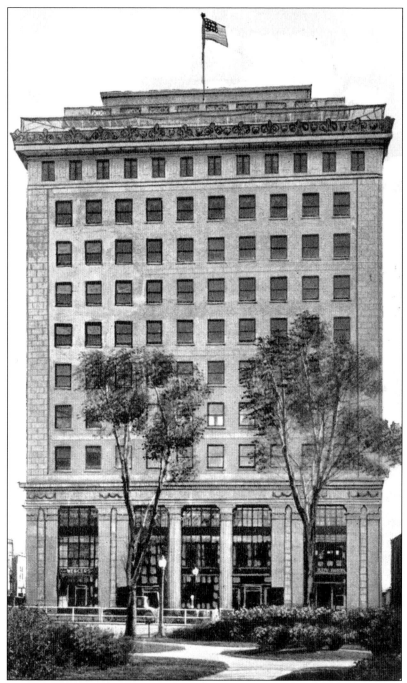

INDUSTRIAL SAVINGS BANK. The bank got this new building in 1923, at North Saginaw Street and Second Avenue. The architecture was said to be inspired by the Temple of the Winds at Athens. After Industrial Bank merged with the Union Trust & Savings to form Union Industrial Bank, this building was known as the Industrial Building, then the CIO Building, and the Metropolitan Building. It is now the Northbank Center, at the University of Michigan-Flint. (Leroy Cole Collection.)

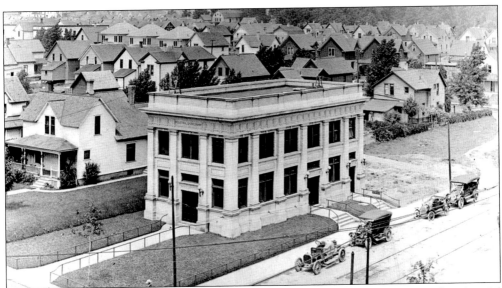

INDUSTRIAL SAVINGS BANK. This bank was headquartered at Hamilton and Industrial Avenue, before it moved to its new building in downtown Flint. This bank building was later used by Citizens, and its classic design makes quite a contrast to the adjacent blue-collar neighborhood. In the 1910–1916 period, Charles S. Mott was the bank president, and Charles Nash was vice president. Nash, President of Buick and then General Motors, left Flint in 1916 to open the Nash Motor Co. (Sloan Museum Collection.)

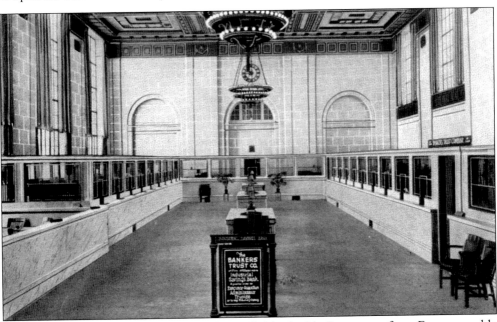

INDUSTRIAL BANK INTERIOR. The bank was finished with Caen stone from France, marble from Italy, and huge bronze doors. Its vault door was reported to weigh 22 tons. The building's upper floors included a track and a gym that was used for high school basketball games, dances, and other events. Also the IMA had a "palatial club room" in the building. (Leory Cole Collection.)

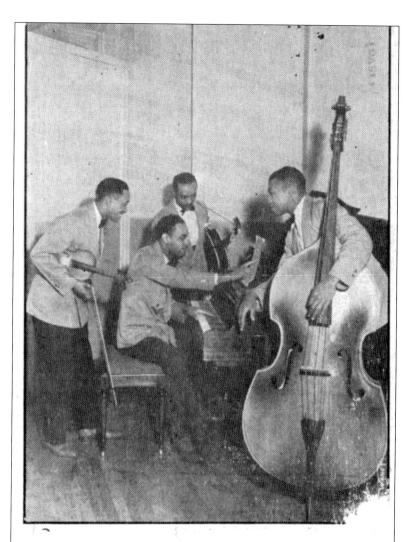

The Swinging Strings
CANTEEN CLUB
Milton Hotel, Flint, Mich.
Personnel:
Claude Williams—Violin
Emmet Adams—Guitar
Churchill Harris, Brilliant Composer—Piano
Lutillus "Lu" Penton—Bass (over)

CANTEEN CLUB AND MILTON HOTEL. The Milton Hotel was located at 4326 Milton Drive, one block east of Saginaw Street near the General Motors Fisher Body No. 1 plant. It was the type of rooming house that appealed to factory workers. The Canteen Club was on the main floor from 1938 to 1946. These were black musicians in a hotel catering to whites. The hotel operated from 1928 to 1964, when the building was torn down. (Wally Eaton Collection.)

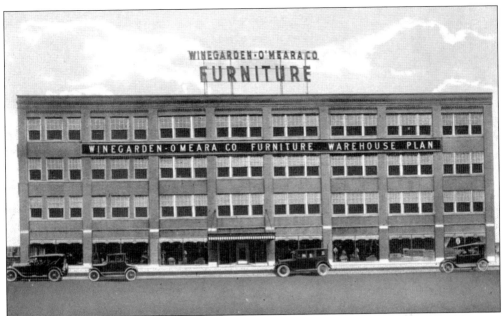

WINEGARDEN-O'MEARA FURNITURE CO. This downtown store opened in 1923, and became better known as Winegarden Furniture. The building was at 125 West Water Street where it was subject to flooding and the owners cited that as one reason that the building closed in 1962; the company's two other local stores remained open. The company made it into "Ripley's Believe it or Not" with "the world's smallest skyscraper." It was a six-story triangular display tower, only seven feet on each side, located on Saginaw Street. (Leroy Cole Collection.)

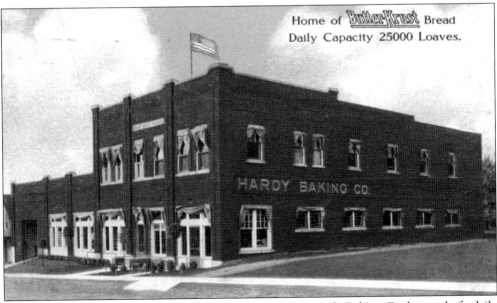

HARDY BAKING CO. Home of "Butter-Krust" bread, the Hardy Baking Co. bragged of a daily capacity of 25,000 loaves of bread. Jessel Hardy founded his first bakery in Flint in 1889. The bakery was later located on Clifford Street, shown here, and in 1932 opened a new location at 1400 Chippewa as Hardy & Sons Bakery. (Dale Ladd Collection.)

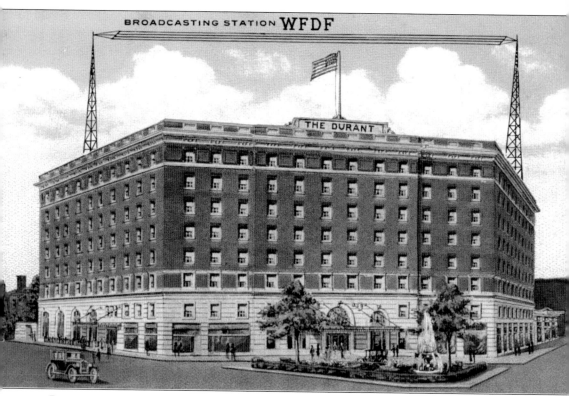

DURANT HOTEL. From 1920, when the hotel opened, until 1973 when it closed, the Durant Hotel was the premier hotel in Flint. The site, at Saginaw Street and Second Avenue, has an imposing view of downtown Saginaw Street. The hotel was named for William C. Durant, founder of General Motors, and had 300 rooms. The Durant suite on the sixth floor contained eight rooms. The first registered guest was Michigan Governor Albert Sleeper. The mezzanine floor ballroom provided dancing space for 500 persons. The hotel was the home of Flint's finest conventions. The building still stands and has been the subject of several proposals for redevelopment. (Bob Florine Collection.)

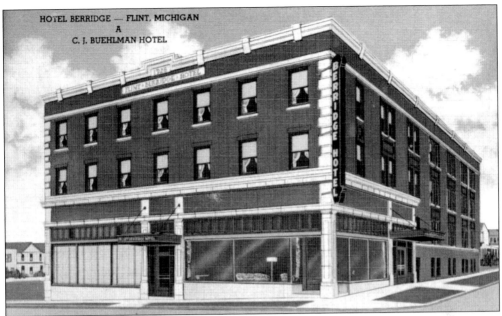

BERRIDGE HOTEL. This hotel was built in 1928 at the southwest corner of Garland Street and Second Avenue on the site of auto pioneer J. Dallas Dort's 21-room home. The hotel cost $200,000 to construct and had 100 rooms at $2.50 to $5 a day. It is now considered a transient hotel. It was built by John Berridge and later sold to C.J. Buehlman, who also owned the Capitol Hotel. (Bob Florine Collection.)

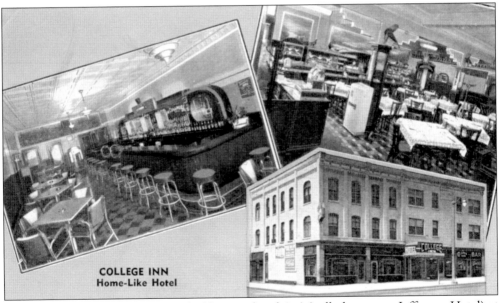

COLLEGE INN. This working man's 40-room hotel (originally known as Jefferson Hotel) at the northwest corner of Detroit Street (now M.L. King) and Second Avenue was opened in 1926. It also had a complete dining room and a bar. The hotel closed in 1958. The bar remained open for years and was last used as a strip bar. The building was razed in 1996. (David White Collection.)

EARL & BRISCOE. These two cars were made in Jackson, and this card is probably from 1921, when the two brands overlapped. The Briscoe was a light car built by Benjamin Briscoe. Briscoe sold the company to Clarence A. Earl, who continued building Briscoes while he began making a car under his own name. (Debbie Propes Collection.)

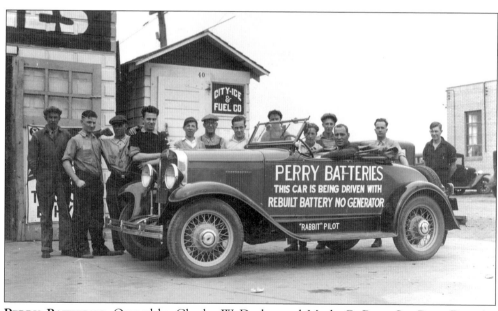

PERRY BATTERIES. Owned by Charles W. Decker and Merle G. Perry Sr., Perry Batteries was a gasoline and oil service station, also offering wholesale and retail battery service. Perry advertised as builders of better batteries, manufacturers of new batteries. This business was located at 3102 Corunna Road from about 1930 to the 1960s. (Sloan Museum Collection.)

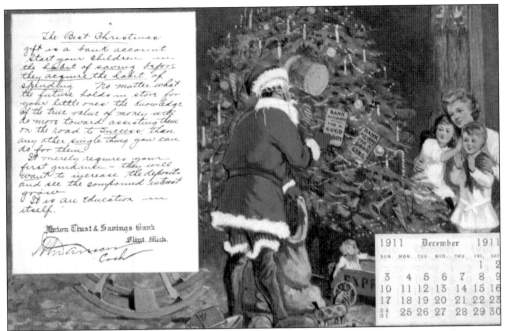

SANTA CALENDAR CARD. This was sent by Union Trust & Savings Bank, which was on the southeast corner of South Saginaw and First Streets, to parents encouraging them to start a bank savings account for their children. It has the signature of M. Davison, cashier. (Jack Skaff Collection.)

OPPOSITE DUR STATION. This is where you could find the Rathbun Barber Shop, Reavely Grocery, and Berridge Drug Store around 1912–1916. The Detroit United Railway, operator of the interurban line and the city's streetcars, had an office and waiting room at 524 North Saginaw Street near Third Avenue. The back of the postcard reads, "4/28 Dear Wilma Got your card tonight. One from Mildred too. We live right back of this drugstore. I buy groceries at the store in the middle. We went to the movies tonight, just got home. Will lays here snoring. Irene." (Wally Eaton Collection.)

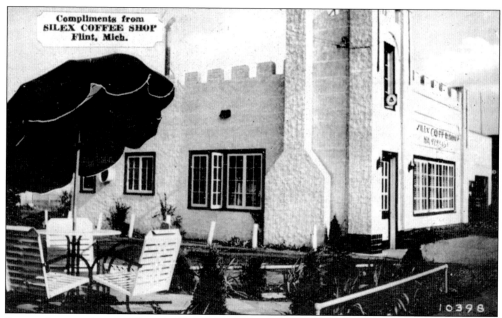

SILEX COFFEE SHOP. Silex Coffee Shop was owned by Willard Johnson. It was located at 3810 North Saginaw Street in the 1940s, and was later known as the Fireside Inn restaurant. (Bob Florine Collection.)

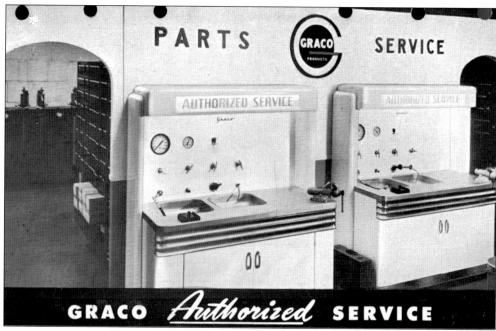

GRACO SERVICE. This is an advertising card from Flint Piston Service. This business was at 704 North Saginaw near Fifth Avenue from 1928 until 1980, when it moved to 3302 Detroit Street before closing a few years later. They sold automotive parts and tools and were a general purpose machine shop, again specializing in automotive work. (Sloan Museum Collection.)

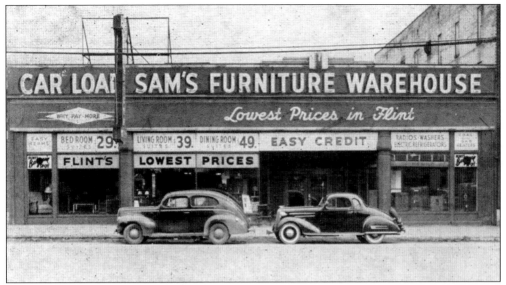

CARLOAD SAM'S FURNITURE. Carload Sam's Furniture was owned by Sam Lande. The business was on East First Street, and known as Flint Furniture Mart. The business was renamed and moved to 908 North Saginaw in 1939. Lande changed the name to emphasize carload buying and low prices. This 1947 postcard was printed with a message from Sam on the other side, urging the recipient to support the re-election of Circuit Court Judge Clifford A. Bishop, who indeed kept his seat on the bench. (Bob Florine Collection.)

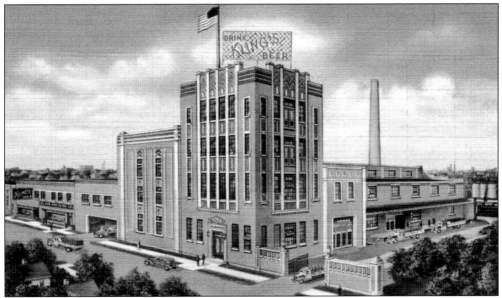

KLING'S BREWERY. This Flint business probably never looked the way it appears in this image. Postcards were sometimes produced to illustrate the way an architect thought the building might look, but the buildings didn't always turn out that way. Kling's Brewery was the former Dailey Brewery, which opened in 1933 at 1521 St. John. On the opening, after a dinner at the Durant Hotel, there was a parade with German band music and floats that went from downtown to the new brewery. (Wally Eaton Collection.)

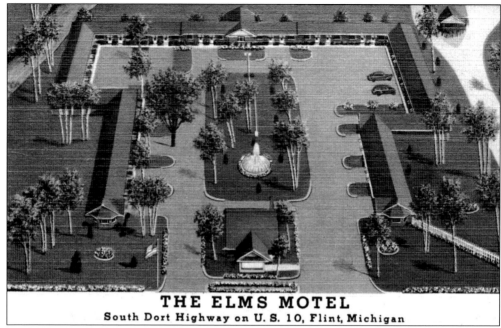

THE ELMS MOTEL
South Dort Highway on U.S. 10, Flint, Michigan

ELMS MOTEL. Originally known as Elms Motel Auto Court, this was said to be Michigan's largest and finest "Motor Hotel" when it opened in 1950. Each of the 44 units had a telephone, radio, bath and shower. It is still operating at 2801 South Dort Highway. (Bob Florine Collection.)

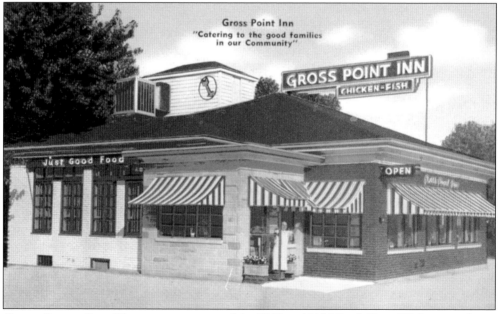

GROSS POINT INN. The restaurant opened in 1942 at 4140 North Dort Highway and was owned by Henry Gross. It added a "tele-tray system" in 1955 for in-car service. The restaurant was bought by Haley Catering in 1961. (Bob Florine Collection.)

Six

KINDERGARTEN TO COLLEGE

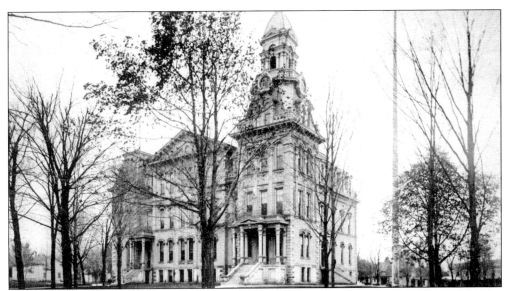

FLINT HIGH SCHOOL. When built in 1873, the first Flint High School was the pride of the community. The building was used until Central High School was built in 1922. For a short time, the building was used as a junior high school until Whittier was built. During the 1936–1937 Sit-Down Strike, the school was used as a barracks for the Michigan National Guard. The building was torn down in 1938. (Bob Florine Collection.)

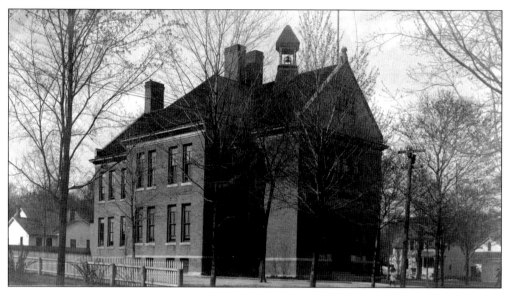

STEVENSON SCHOOL. This building served as the first Stevenson School in the 1800s until a new one was built on Sixth Avenue in front of Hurley Hospital in 1911. When the school was first built, there was no running water in the building, but a pump was located outside. With the crowding of the schools, the building was put back into use as the Rankin School, a unit of the Doyle School. The building was located at Second Avenue and Lyon Street. (Wally Eaton Collection.)

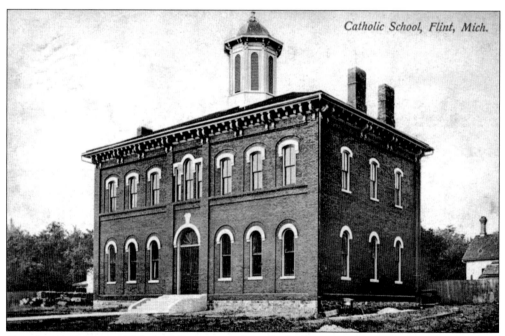

CATHOLIC SCHOOL. This building was originally built as a school to serve St. Michael Catholic Church on Chippewa Street. When the new school was built on Fifth Avenue this building was used for a short time as the School of Automotive Trades, which would later become General Motors Institute. (David White Collection.)

CLARK SCHOOL. The first Clark School was built in 1878 and was named after John Clark, a local druggist and doctor who worked at the Michigan School for the Deaf. Clark was considered the father of the public school system in Flint. The new school was built in 1912, but architects and contractors realized they had made a mistake in construction when a steel structural support was found in the middle of the school gymnasium, making it impossible to play basketball. The school was closed in 1971. (Leroy Cole Collection.)

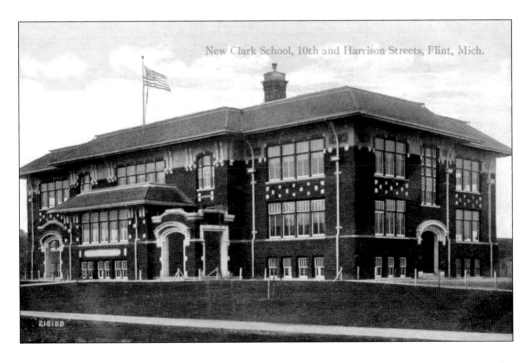

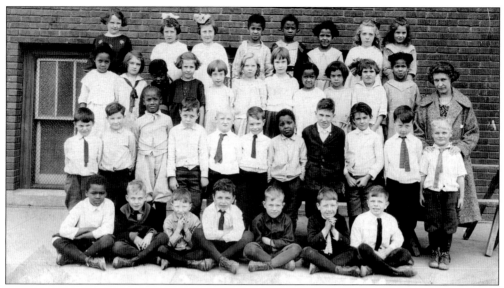

CLASS AT CLARK SCHOOL. This class from Clark School was representative of the diversity of Flint schools. Like many Flint schools, the quick expansion of the community demanded units of the school be built to relieve overcrowding. Clark's school units were located on Pingree Street and on Lippincott near Dort Highway. The units served over 300 students. (Sloan Museum Collection.)

KEARSLEY SCHOOL. This Kearsley School was located on Kearlsey Street where the Sloan Museum stands today. The first building was built in 1892 to relieve the crowding at Walker School, then located on Second and Harrison streets. Several additions were made to the school as the city grew. The principal was Carrie Cronk, who also was the first grade teacher. The principal's office was in her closet. The building was torn down to make room for the College and Cultural Center. (Sloan Museum Collection.)

WALKER SCHOOL. This school was the second school building to carry the name of Walker. It was located on the current site of the YMCA. Its construction caused quite the stir in the community when a large grove of oak trees was cut to make room for the school. The school is named in honor of Levi Walker, a president of the school board who served for 25 years. Walker School was one of the first schools to have fluorescent lighting installed in 1945. (David White Collection.)

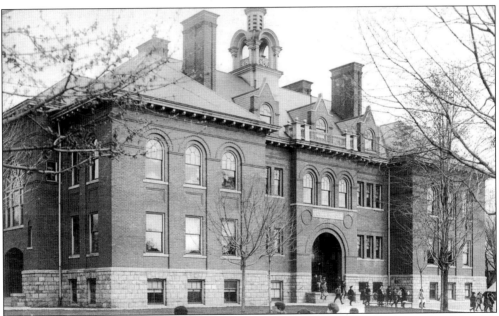

DOYLE SCHOOL. The first school on this site was built in 1848 and was replaced by this building in 1901. Serving the north side of the river, the school was often crowded and had a unit at Second Avenue and Lyon Street called the Rankin School. The school was closed in the early 1970s only to be renovated a few years later to serve the new housing in the area, and named Doyle-Ryder. (Sloan Museum Collection.)

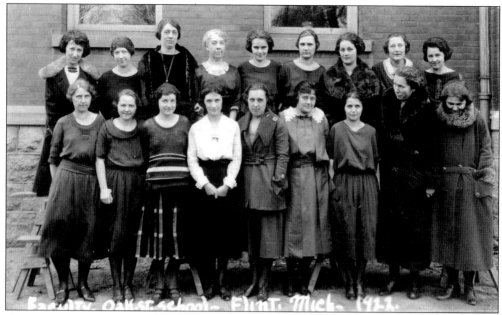

OAK SCHOOL FACULTY. Teachers of the early 20th century did not make much money and working conditions were not the best. Few schools prior to 1912 had running water or electricity. Teacher salaries averaged about $320 a year. (Sloan Museum Collection.)

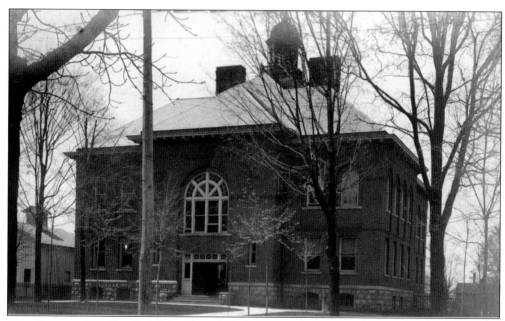

OAK SCHOOL. The first Oak School was built in 1855 and was replaced by this structure in 1896 with improvements being made in 1908. It is said that the cupola from 1896 is in the attic of the school. Lacking a gym, the school would use the gym at Court Street Methodist Church until an addition was made to the school in the 1950s. The school was closed in 1976. Community Mental Health took over the building for offices shortly thereafter. (Wally Eaton Collection.)

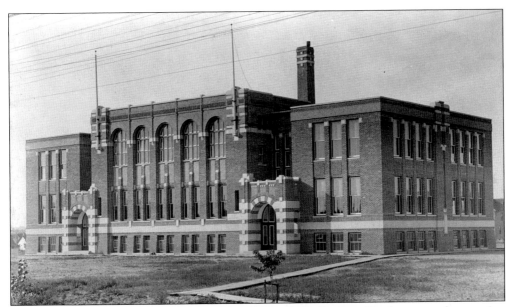

HOMEDALE. Homedale School was built in 1918 at 1501 Davison Road to meet the growing needs of the community. Due to declining enrollments in the Flint schools, it was closed in 2003. (Sloan Museum Collection.)

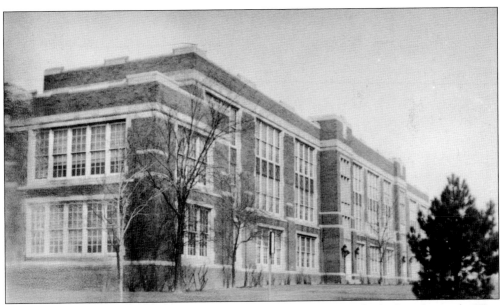

LONGFELLOW SCHOOL. Built in 1927, the Longfellow School was often referred to as the West Junior High School. The school became a key benefactor of the Mott Community School programs and often hosted C.S. Mott and visitors interested in learning more of the Community School concept. The Longfellow PTA was the first group of parents in Flint to officially recognize the good works of their teachers with a plaque. The plaque was accepted on behalf of all the teachers by longtime English teacher, Paul Wightman. (Wally Eaton Collection.)

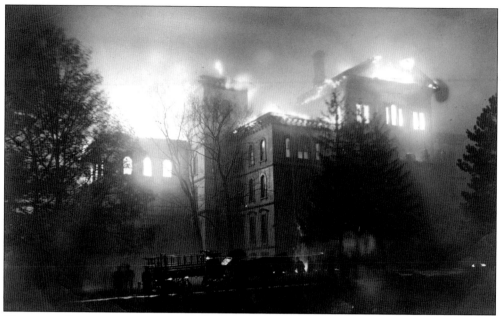

MICHIGAN SCHOOL FOR THE DEAF FIRE. On May 21, 1912 around 10:30 pm, fire broke out in the MSD Administration Building, known as Fay Hall, after lightning hit the building. Children were quickly evacuated by older students. Difficulty in getting equipment to the scene and the lack of water pressure prevented the fire department from doing anything more than protecting the adjoining buildings. (Leroy Cole Collection.)

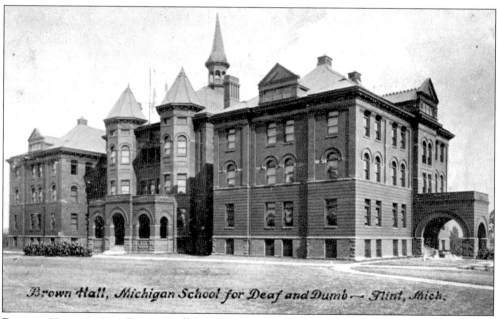

BROWN HALL, MSD. Brown Hall was built on the Michigan School for the Deaf Campus in 1899 to meet the growing needs of the school. The building was used for classroom space and was ready for use the following year. (Bob Florine Collection.)

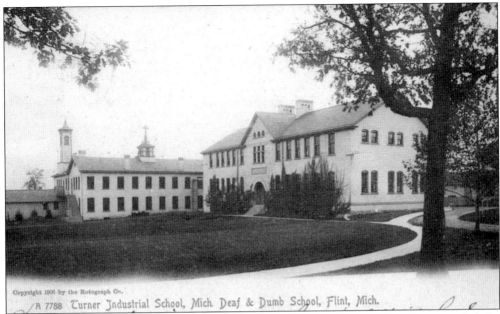

TURNER INDUSTRIAL SCHOOL AT MSD. The Michigan School for the Deaf provided the students every opportunity to learn trades to use in the real world. The campus was complete with a farm, dairy cattle, and carpentry and printing shops. Turner Hall was built in 1897. (Bob Florine Collection.)

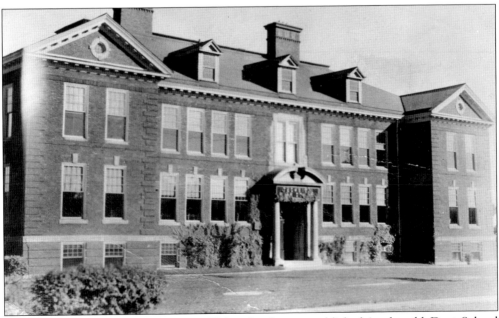

FLINT TECHNICAL HIGH SCHOOL. This school was established in the old Dort School especially for students with good grades. Established in 1939, this school operated until Southwestern High School was built in 1959. (Bob Florine Collection.)

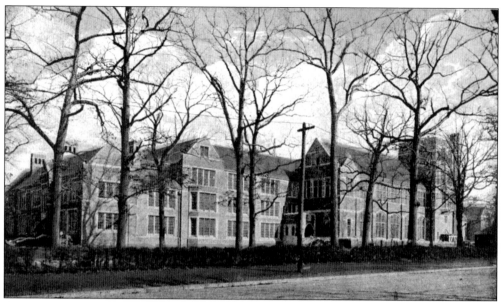

CENTRAL HIGH SCHOOL. Central was built in 1922 and was the second high school to be built in the city. It replaced the old Flint High school that opened in 1875. The school was built on the grounds of the old Oak Grove Sanitarium. (David White Collection.)

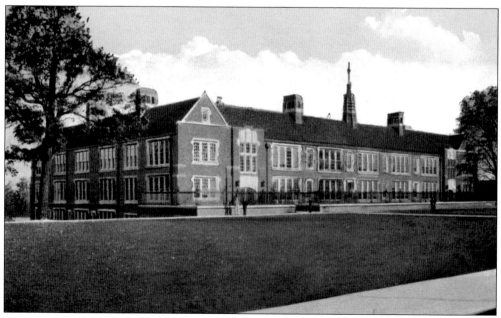

WHITTIER JUNIOR HIGH. Whittier was built alongside Central High School on a 570-acre plot that was originally owned by Governor Crapo, intended for his estate. Built in 1925, the school was named in honor of the poet John Greenleaf Whittier. (Sloan Museum Collection.)

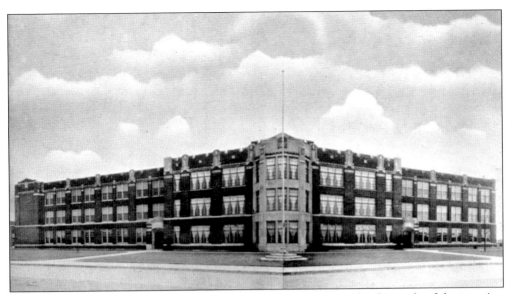

NORTHERN HIGH SCHOOL. Northern opened in 1928 to meet the demands of the growing neighborhoods in the northern part of the city. The school was opened with a parade down Saginaw Street to Third Avenue where the participants then boarded the trolley that took them to the school. The school was located on McLellan Street and was built in the Academic Gothic Style. (Bob Florine Collection.)

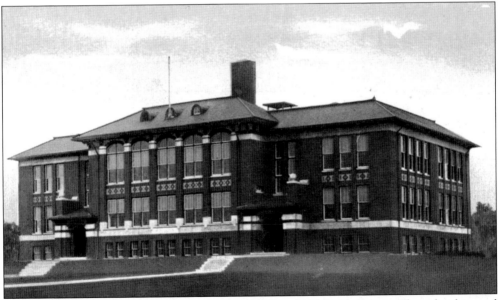

FAIRVIEW SCHOOL. This school opened in 1915 at 1300 Leith Street. The school served the St. John Street Community which had 27 different nationalities. The teaching staff was challenged by the number of children who did not speak English. The school became a model for the community school concept, leaving its doors open seven days a week for the community to use, offering classes to adults and providing breakfast to the students. The school closed in the early 1970s and the property was acquired by General Motors for the expansion of Buick. (David White Collection.)

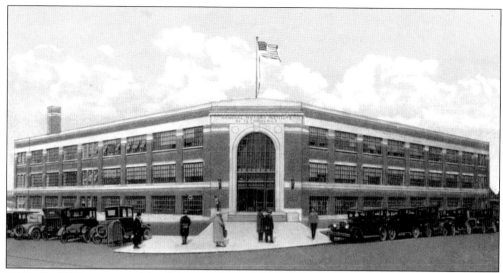

GMI. In 1919, sponsored by the Industrial Fellowship League, Albert Sobey created a night school for employees of the Flint area industries. By 1924, enrollment had increased to 600, and four-year cooperative programs in engineering and management were begun under the name of the Flint Institute of Technology. In 1926, General Motors agreed to underwrite the school and to extend services to all units of the corporation. The school became the General Motors Institute and was a pioneer in cooperative education. In 1982, the school established itself as a private college, and in 1998 the name was changed to Kettering University. (Bob Florine Collection.)

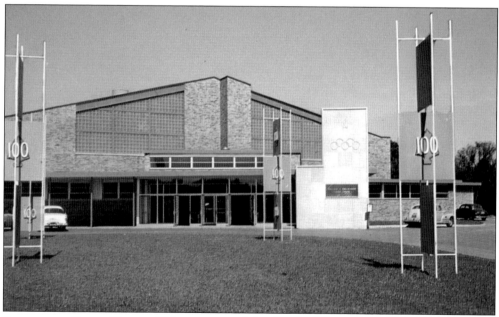

BALLENGER FIELD HOUSE. This was one of the first buildings built on the Mott College Campus. It was named in honor of William Ballenger, a Flint banker and auto industrialist. This photo shows the front of the building, decorated for the city's centennial celebration. (John Straw Collection.)

Seven

SERVING THE COMMUNITY

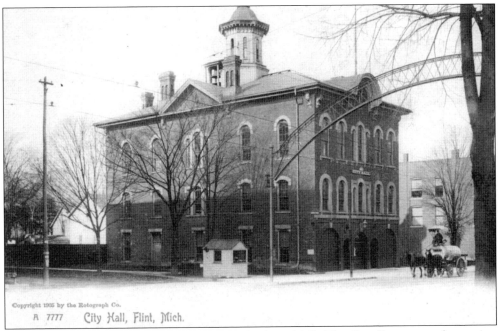

Copyright 1905 by the Rotograph Co.

A 7777 City Hall, Flint, Mich.

CITY HALL. The first city hall building was built in 1863. The first floor was a fire station and the second floor served as Flint's first high school until 1875, after that it was city council chambers and firemen's living quarters. The third floor was "town hall" and home of the Humphrey Dancing Academy. The building was razed in 1907. (Bob Florine Collection.)

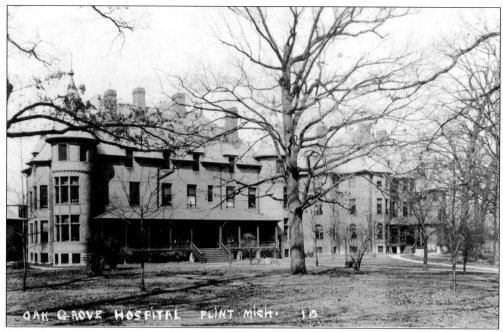

OAK GROVE SANITARIUM. This hospital was established in 1891 as a private psychiatric care hospital by Dr. C.B. Burr. The site was a 60-acre grove of oak trees where Governor Crapo had anticipated building his estate. The hospital operated until 1920 the buildings were subsequently used as a residence club for unmarried teachers. From 1935 on, the buildings were used by Flint Junior College and Central High School. The buildings were razed in the 1950s. (Bob Florine Collection.)

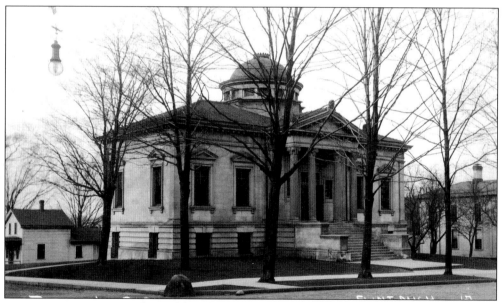

FLINT PUBLIC LIBRARY. Flint Public Library was constructed in 1904 with the help of a $25,000 grant from Andrew Carnegie. A new library was built in 1962, after which the old building was leveled. The pillars are now at 423 Weller Street in Mott Park. (Sloan Museum Collection.)

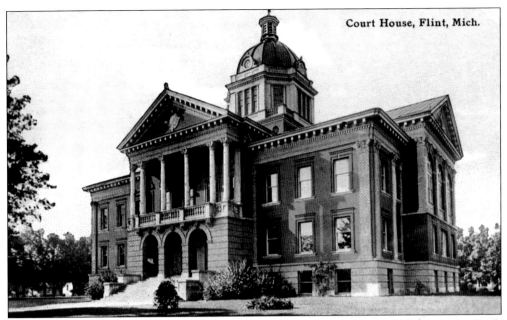

GENESEE COUNTY COURTHOUSE. This was the third courthouse built on the same site. Built in 1904, it burned March 14, 1923. Also destroyed in the fire were bronze plaques listing the Civil War veterans of Genessee County. These were never replaced. The present courthouse was built in 1925 on the same site. (Dale Ladd Collection.)

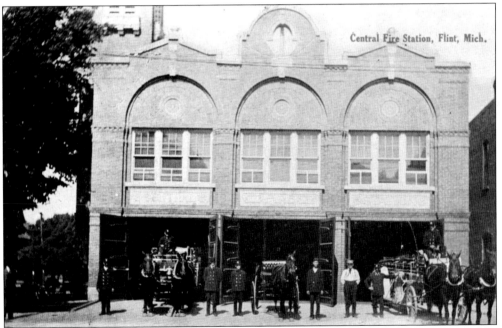

CENTRAL FIRE STATION. Horses were used to pull fire vehicles until about 1915 when the entire department was motorized. The last two horses were "Dan" and "Prince." The Central Fire Station moved from the old city hall building to a new building at Fourth Street *c.* 1909. (David White Collection.)

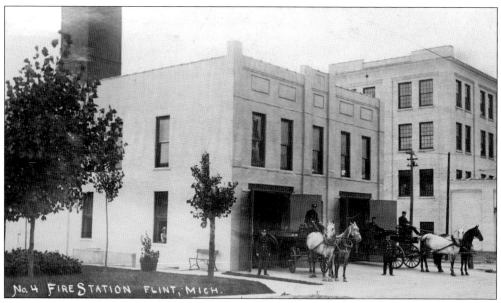

NO. 4 FIRE STATION. This fire station was located on Industrial Avenue south of Hamilton Avenue. This was the local fire station for the Oak Park neighborhood and Buick factory area. The buildings are now gone. (Jack Donlan Collection.)

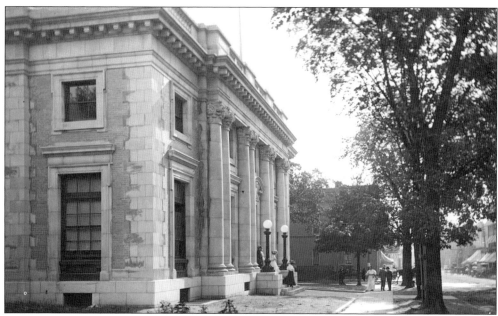

KEARSLEY STREET POST OFFICE. The building was built in 1905 and operated as a post office until 1931, the building housed federal offices until 1944 and was the headquarters for Red Feather from 1945 on. The building was razed in 1966. (David White Collection.)

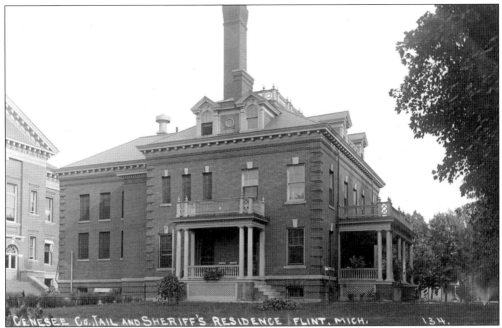

SHERIFF RESIDENCE. A tradition for many years was that the county sheriff's residence was attached to the county jail, which sat behind the courthouse. This arrangement afforded additional security as well as a source of food for the prisoners. This practice was discontinued in 1930 when the jail and residence shown here were demolished to make room for a much larger jail to serve the county. (Sloan Museum Collection.)

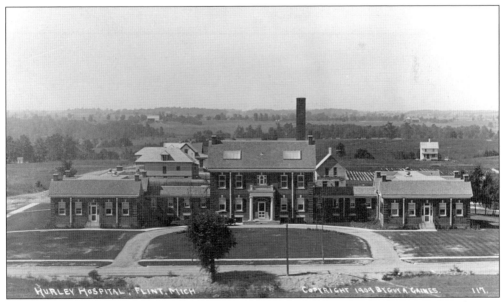

HURLEY HOSPITAL. The Flint city hospital was built in 1907 on the highest point in the city. It was funded, in part, by James T. Hurley. Hurley owned a soap factory located on the river near Grand Traverse Street. (Sloan Museum Collection.)

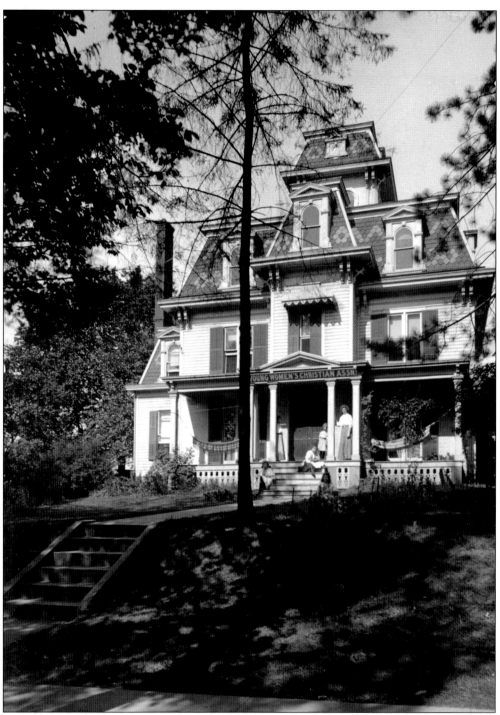

YWCA. The YWCA was incorporated in 1908 and used the former Oren Stone House as its first headquarters. Their second facility was built in the 1920s at First and Harrison Streets. A new building was dedicated Nov. 24, 1968, on Third Street, and the old building was razed in 1976 for a parking lot. (Sloan Museum Collection.)

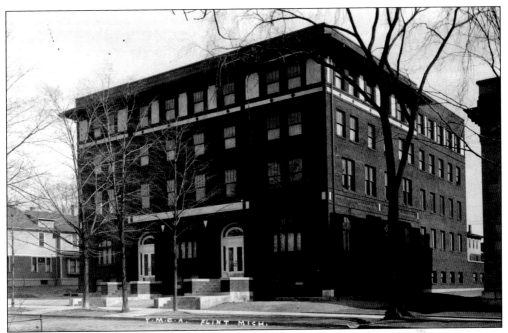

YMCA. Flint's YMCA was established in 1913. The "Y" opened in this building on Kearsley Street in 1914 and operated there until the current building opened in 1962 at Third and Stevens Streets. (Sloan Museum Collection.)

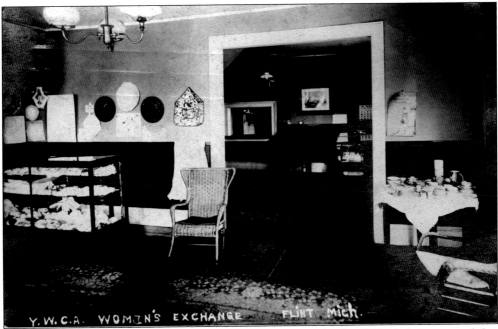

YWCA EXCHANGE. This rare photo shows the interior of the first YWCA. It is assumed that this is a sales area for the women. The YWCA provided housing for the women who came to work in the factories. (Sloan Museum Collection.)

FLINT POLICE HEADQUARTERS. This was the St. Matthews Roman Catholic School until about 1921. Then from 1921 to 1958 it was Flint police headquarters, after which it was razed. (David White Collection.)

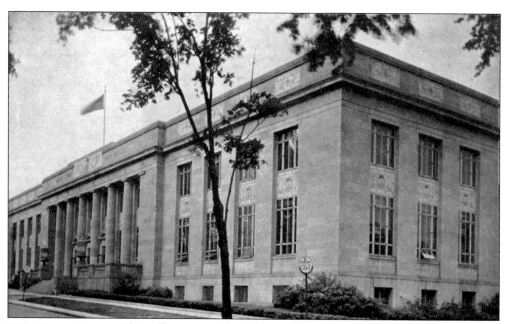

U.S. POST OFFICE. This office opened in 1931 and was used until the 1960s when it was converted to federal offices. (Jack Donlan Collection.)

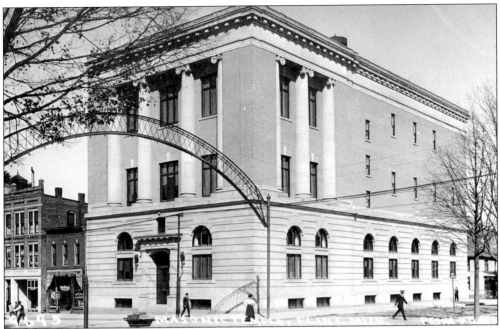

MASONIC LODGE No. 23. This building was built in 1911 when the ranks of the Masons were expanding. Still in use today, the basement is the Battiste Dining Room, a popular dining place downtown. (David White Collection.)

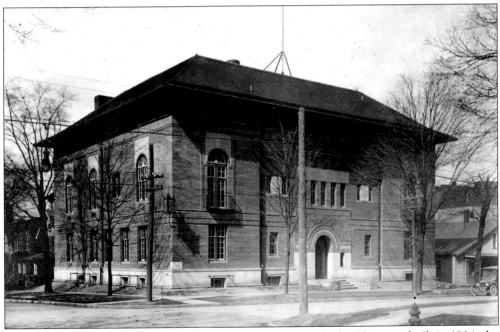

ELKS LODGE No. 222. Elks were formed in Flint *c.* 1891. The building was built in 1914; the Elks club moved out in 1970 and sold the building, which is used as an office building. This was one of the first Flint buildings added to the National Register of Historic Places. (Sloan Museum Collection.)

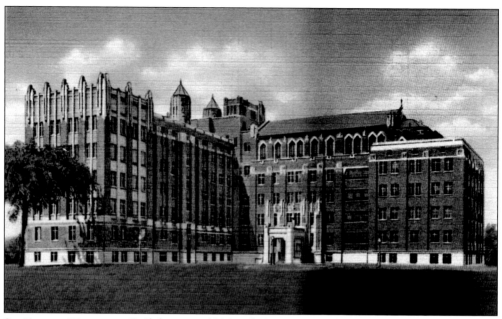

ST. JOSEPH HOSPITAL. Built between 1936 and 1941, St. Joseph Hospital was Flint's Catholic Hospital. It is now part of Genesys Regional Medical Center in Grand Blanc. The building was razed in 2000 after the new hospital was built in Grand Blanc. (Bob Florine Collection.)

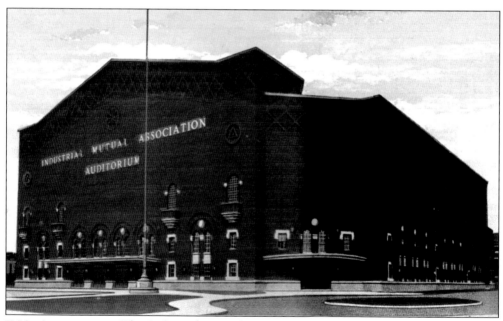

IMA AUDITORIUM. The Industrial Manufacturers' Association was organized in 1901 as a non-profit benefit association. The auditorium was built in 1929. It and its annex were closed in 1979. Autoworld was operating there by 1984, and was officially closed in 1990. The building was demolished in January of 1997. (Jack Donlan Collection.)

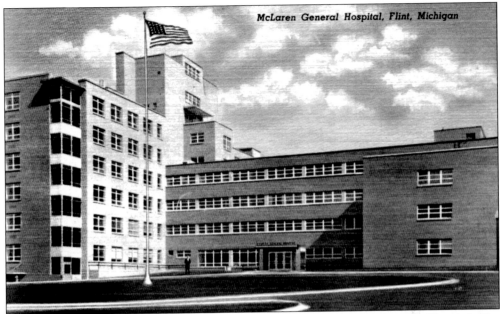

McLaren General Hospital. This hospital was founded in 1919 as Women's Hospital. The present facility was built in 1951. It is named after Margaret McLaren who was superintendent at the Women's Hospital on Lapeer Street for 28 years. (David White Collection.)

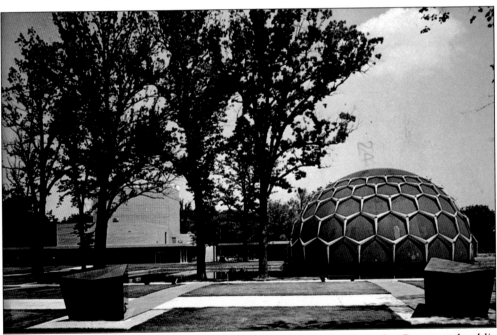

Longway Planetarium. The planetarium, Bower Theater, DeWaters Art Center, and public library were the first new buildings in the Cultural Center along Kearsley Street, joining the Dort house that became the Dort Music Center. The planetarium was built in 1957, and was named for Robert T. Longway, chairman of the center's committee of sponsors from 1954 to 1960. (Bob Florine Collection.)

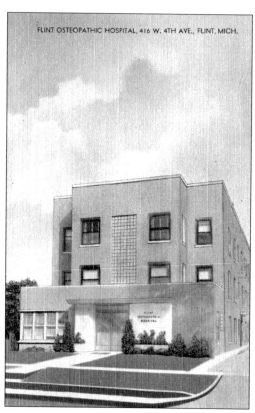

FLINT OSTEOPATHIC HOSPITAL, 416 W. 4TH AVE., FLINT, MICH.

FLINT OSTEOPATHIC HOSPITAL. This hospital was founded in 1935 by Dr. A.J. Sill on Detroit Street. It was situated at 416 West Fourth Avenue from the 1940s until *c.* 1960. It was razed when a new hospital was built on Ballenger Highway. FOH is now a part of Genesys. (David White Collection.)

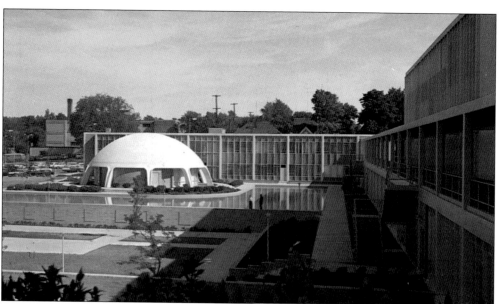

CITY HALL. The new Flint City Hall, complete with Fire and Police Station on one site, was built as a Flint centennial project. Vice President of the United States Richard Nixon was part of a dedication ceremony while here to participate in the Centennial Parade. An elaborate garden with a pond around the Health Dome was in the rear of the building. (Debbie Propes Collection.)

Eight

LIVING IN FLINT

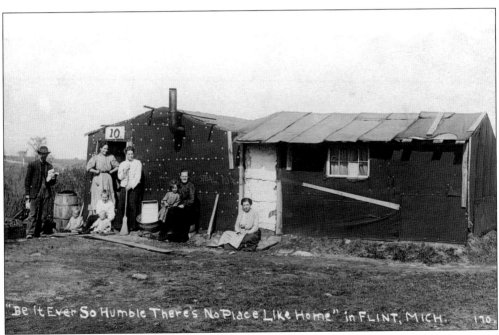

TARPAPER SHACK. People seeking a place to live when they came to work at Buick created homes with whatever material they could find while they waited for a real home. Piano and shipping crates provided the cheapest material to build a temporary home; other workers lived in tents. (Dale Ladd Collection.)

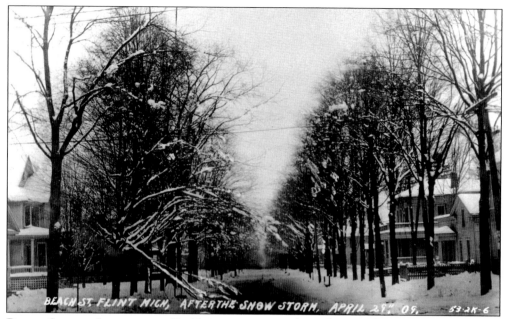

BEACH STREET SNOWSTORM. Residents were not as dependent on their own transportation as we are today, using public transportation and walking instead of driving. It was rare to see schools and businesses close due to a storm. (David White Collection.)

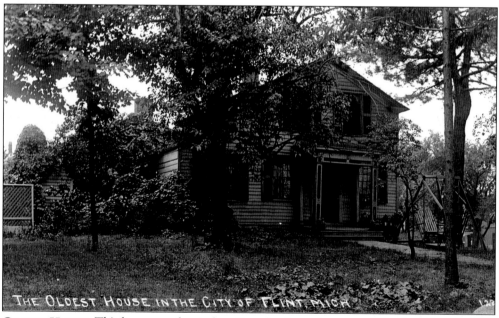

OLDEST HOUSE. This house was located on Kearsley Street just east of Harrison Street where the U of M-Flint parking ramp is today. The house was torn down in 1913 to make room for the first YMCA. It was sold at auction for $41 and moved to the Darling farm on Court Street where it was used as a barn or chicken coop. (Jack Donlan Collection.)

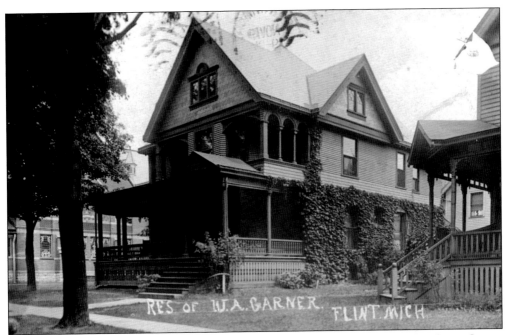

W.A. Garner House. The home of William Garner was located at 305 West Court Street. Garner was a realtor in the early 1900s. (Jack Skaff Collection.)

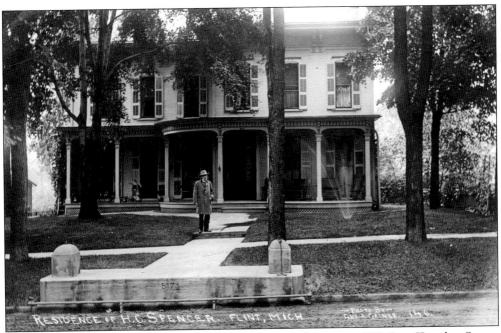

Horace Spencer Home. The Spencer Home was located at 517 East Kearsley Street. Spencer started as a cashier at Citizens Bank and after 15 years, became a director of Genesee Bank in 1885. He served as a state senator and mayor of the city. He served on the park board for five years. His daughter married Arthur G. Bishop. (Sloan Museum Collection.)

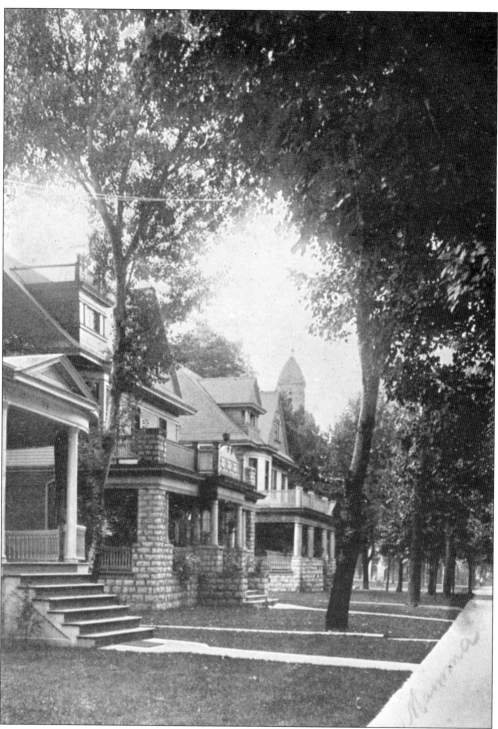

BEACH STREET. Beach Street south of Fifth Street developed quickly in the early 1900s and many businessmen and professionals built their homes within walking distance of downtown. (Bob Florine Collection.)

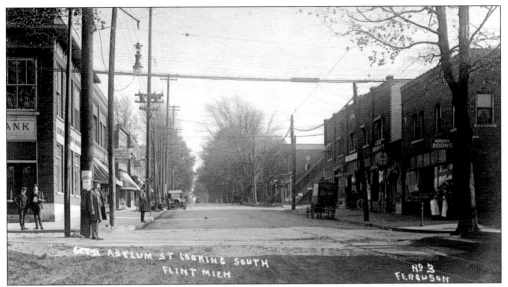

ASYLUM STREET. This card is from *c.* 1919 looking south on Asylum Street from Kearsley Street. A Genesee Bank branch office is in the left foreground while across the street is the O.K. Restaurant beneath a furnished rooms facility. The Horton Jeweler is the next business south. The horse-drawn wagon is from Trojan Laundry. This neighborhood business district was within a block of the Chevrolet manufacturing plants and many of the businesses were geared to the factory trade. (Debbie Propes Collection.)

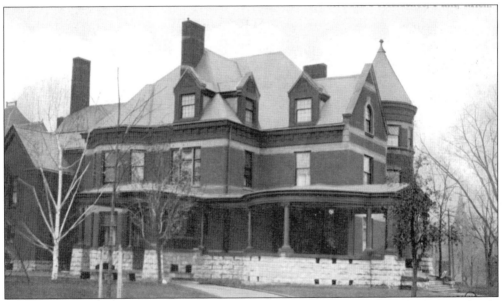

PATERSON RESIDENCE. The home of pioneer carriage maker William Paterson and his family was located at 310 East Third Street where the YWCA currently stands. This was one of many homes and buildings Paterson built in the community. The house was designed by Pratt and Koepke of Bay City. The home had 24 rooms on four floors. Built in 1898, Paterson considered it his masterpiece, having learned from his previous projects. The house had three and one-half bathrooms, making it one of the finest homes in its day. (Bob Florine Collection.)

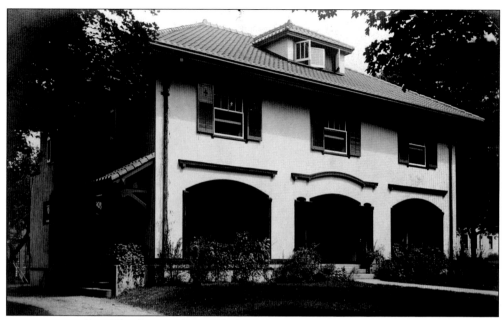

MOTT RESIDENCE. The first residence of Charles S. Mott was also located on Kearsley Street, at the corner of Liberty. After the Motts moved into their new house, Walter Chrysler and Albert Champion lived in the home for a short period of time. It was demolished for the U of M-Flint campus in the 1970s. (Sloan Museum Collection.)

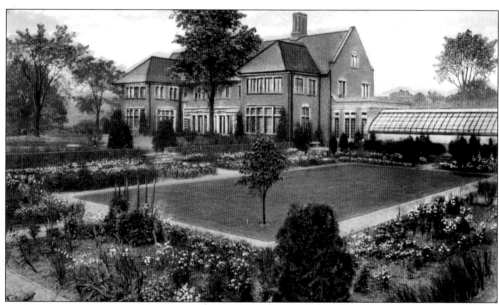

MOTT HOME AND GARDENS. This was the second home of Charles Stewart Mott to be built in the city. The property was at the city limits when Mott purchased 26 acres from J. Dallas Dort and 38 acres from Charles Nash in 1916. Mott's brother-in-law, Herbert Davis, designed the house in the American Tudor style, also referred to as the Neo Jacobean style. Mott donated 32 acres for the creation of the Mott College and U of M campuses in 1952. The estate is called Applewood for its large apple orchard. (David White Collection.)

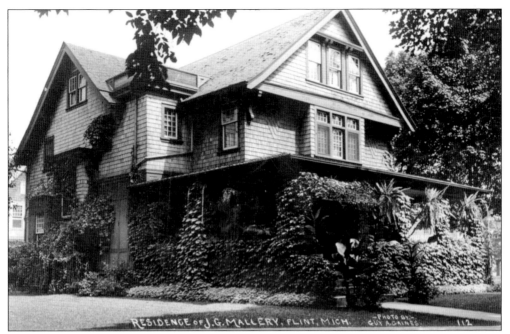

MALLERY RESIDENCE. The Mallery residence was located at 526 East Kearsley Street. James was the owner of the Flint Buggy Company. His son, Harvey, also worked at the buggy company and later became vice president and comptroller at Buick. Upon James' death, Harvey and his family moved into the Kearsley Street residence. Harvey served as mayor of the city in the 1930s. (Sloan Museum Collection.)

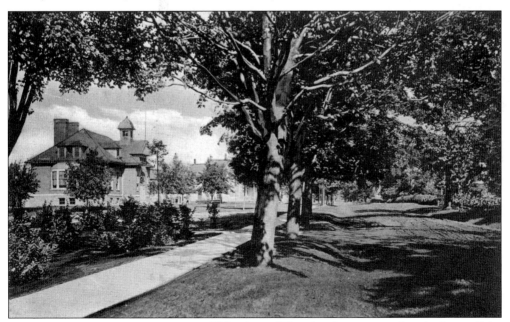

KEARSLEY STREET LOOKING EAST. This view of Kearsley Street was taken in front of the Dort Residence not far from the corner of Crapo Street. The Kearsley School was located where the Sloan Museum is today. (Sloan Museum Collection.)

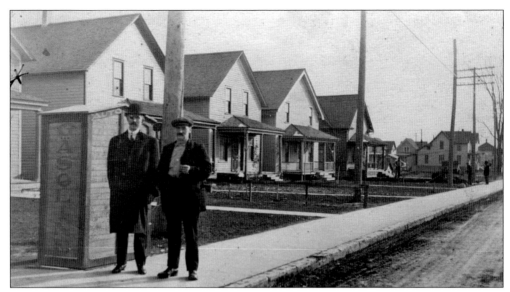

NEIGHBORHOOD GAS STATION. The caption on the reverse side identifies the location as Saginaw Street. By the appearance of the new residences, this is North Saginaw somewhere between Page and Leith Streets *c*. 1910, and based on the shadows it is probably the east side of the street. The small building near the men has the words "gasoline " and "auto" on the sides. This is a filling station with a hand-operated gasoline pump for automobiles. A car owner would fill a can with gasoline and then carry it to the vehicle. A nearby merchant would collect the money. Sloan Museum has a similar station on display. (Sloan Museum Collection.)

MRS. HENAGIR'S BOARDING HOUSE. This is typical of boarding houses for factory workers for nearby Buick. The house was built about 1909 at 729 East Paterson Street, and its last known date as a boarding house is 1931. The house was lost to urban renewal in the 1970s. (Wallace Eaton Collection.)

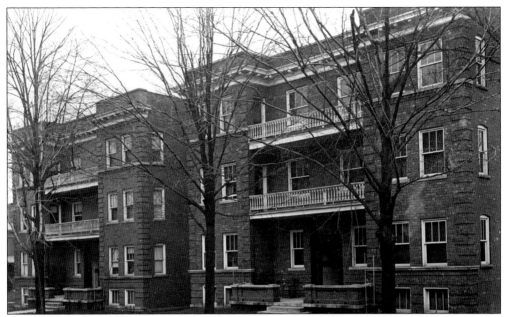

PENFIELD/BROOKS. The Penfield and Brooks were built in 1907 by pioneer lumberman Flint P. Smith as apartment buildings. They were considered modern apartment buildings for the times with five or six rooms and a bath. They were on East Kearsley Street between Stevens and Liberty Streets in an area of fine homes. The apartments remained in use until 1975 when they were purchased by the U of M-Flint. In 1978 they were razed for the expansion of the university campus. (Jack Donlan Collection.)

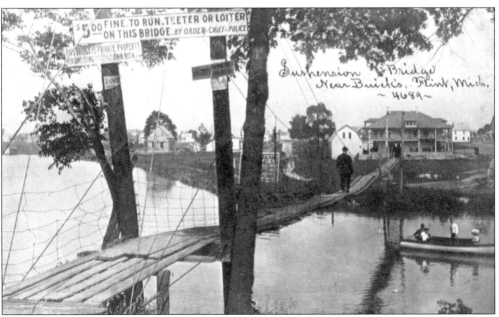

FOOTBRIDGE NEAR BUICK. Many of the workers at the industrial plants located along Hamilton Avenue lived near the plants but across the river. The residents living on the east side of the river built this rope bridge to provide a faster walking route to work. (Bob Florine Collection.)

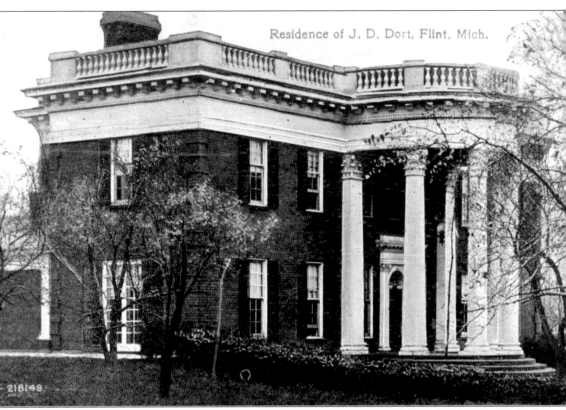

Residence of J. D. Dort, Flint, Mich.

DORT RESIDENCE. The Dort residence at the corner of Crapo and Kearsley Streets was built in 1906. Prior to this time, the Dort family resided on Garland Street in Carriage Town. Jarvis Hunt of Chicago was the architect and the grounds were designed by Warren Manning of Boston. Warren Manning was hired by Dort at his own expense to create a park plan for the city of Flint. The house became the home of the Flint Institute of Music in the 1950s and was ruined by fire in the 1970s. (Dale Ladd Collection.)

BOARDING HOUSE. Several boarding houses were located in the area of the Buick factories. It is believed that this one was on E. Witherbee Street about one-half a block from Buick. The city directory shows a boarding house run by Mrs. Ella L. Pierson, at 820 W. Witherbee. The directory also shows a dressmaker, Claudia M. Pierson, at that address. The card was sent on October 24, 1909. The sender, W.B. Abbott, wrote to his "Ma": "This is a picture of the Boarders where I get my meals." (Bob Florine Collection.)

R. SPENCER BISHOP HOME. The R. Spencer Bishop home was designed by Robert Seyfarth, an architect from Highland Park, Illinois. The house was built by Carl Bonbright in 1918. The library has a fireplace taken from the home of Bishop Moore, author of *'Twas The Night Before Christmas*, in Chelsea, New York. The house became Sanford House Interior Decorating in 1951 which operated there until 2001. (Sloan Museum Collection.)

ADAMS AVENUE. The area off of Detroit Street (now M.L. King) was developed in the 1915–1920 era to meet the growing demands for housing in the city. The close proximity to Buick and downtown made the area an attractive place to live. (Bob Florine Collection.)

RICHFIELD ROAD. This road was named Richfield until 1924, when it became Lewis Street. From the presence of streetcar tracks, a curve in the street, a slight hill, and the concrete wall, this photo was taken from the intersection of Lewis Street and Davison Road before 1925 looking southwesterly. I-475 currently crosses this street down the center of the picture. (Sloan Museum Collection.)

Nine

OLLA PODRIDA

FLINT FERRY. The *City of Flint* was a car ferry that transported rail cars across Lake Michigan between Ludington and Manitowoc for the Pere Marquette Railroad and later the Chesapeake & Ohio Railroad, from about 1929 to 1969. The ship was 381 feet long, could carry 30 loaded rail cars, had 40 staterooms and 5 parlors, and had provisions to carry passenger automobiles. It was converted into a river barge hauling freight across the Detroit River. (Jack Donlan Collection.)

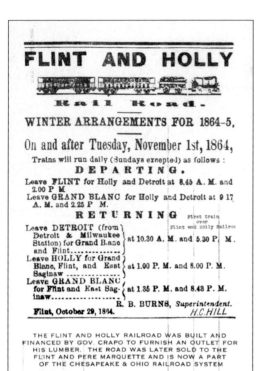

TWO TRAINS DAILY. In 1864, when this schedule was printed in the *Wolverine Citizen* newspaper, the Flint & Holly Railroad was running two trains per day to Detroit and back. The Flint & Holly line was built by Henry H. Crapo in 1864 as a way to get his lumber to more markets. It later became part of the C&O Railroad. The other major rail line to Flint, the Flint & Pere Marquette, arrived in 1862 and eventually became part of the Grand Trunk Railroad. (Sloan Museum Collection.)

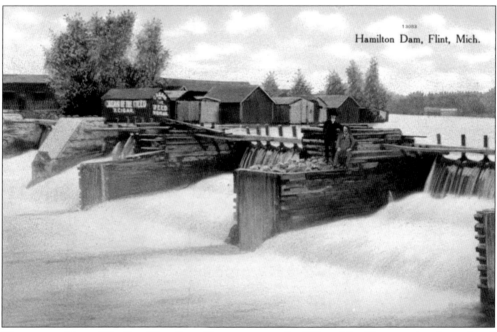

HAMILTON DAM. The first Hamilton Dam was a crude affair, with pilings made of wood and filled with rocks, and wooden gates between the pilings. The dam created a water source for the Hamilton flour mill, which was served by a mill race on the south side of the river, and the Crapo lumber mill on the north side. (Bob Florine Collection.)

120

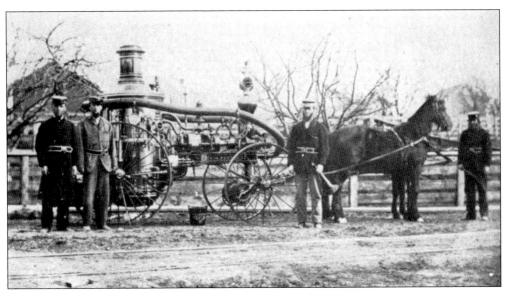

FLINT FIREFIGHTERS, 1870. This image shows a Silsby No.2 engine steamer purchased August 11, 1867 and called the "Colonel Fenton." Fenton was the name of the first Flint fire chief, appointed on January 1, 1855. He died at a fire scene on November 11, 1871. The horses were commissioned from nearby owners for each fire run. The communication bugle held by the fireman in the middle is on display at the Sloan Museum. The last fire horse was retired in 1915. (Joe Guerin Collection.)

MAMBRINO GIFT. This Flint-owned horse, "Mambrino Gift," set a world record for a trotting stallion with a mile time of 2:20 in 1874. A $40,000 purchase offer was refused by the owners. An oil painting was made of the horse and track times were printed on postcards and in city directories. When the stallion, owned by I.M. and H.D. Nye and Tom Foster of Flint, died in 1877, its carcass was stuffed and exhibited in a local harness shop. (Jack Donlan Collection.)

HACKMEN'S UNION

Flint, May 1, 1895.

We, the undersigned, hackmen of the city of Flint, Genesee County, Mich., hereby form ourselves into an association for mutual protection, and hereby agree upon the following schedule of prices:

FUNERAL OCCASIONS.

To Catholic Cemetery	- - -	$3 00
" Glenwood Cemetery,	- - -	3 00
" Avondale Cemetery,	- -	2 50
" City Cemetery and addition,	- - -	2 50
" Funerals from House to Depot,	- -	2 00
" Whigville Cemetery,	- - -	4 00
" Mt. Morris Cemetery,	- - -	5 00
" Flushing Cemetery,	- - -	5 00
" Atlas Cemetery,	- - - -	6 00
" Bristol Church from Flint,	- - -	4 00
" Lennon,	- - $6 00; 2 Trips,	$8 00
" Any place within 5 miles of Flint,	- -	4 00

Signed, JAMES McDERMOTT,
W. J. TAYLOR & CO.
GEORGE D. WILSON.
L. C. SHRADER.
W. L. PARKER.
JAMES O. MARSH.
ED. BABCOCK.
THOMAS CHEATAM.
I. J. STERLING.
ENOS SULLIVAN.
J H. SHRADER.

HACKMEN'S UNION. In 1895, hack drivers in Flint got together and set this table of rates for various trips. This was one of the earliest unions in Flint, but not the first—the cigar-makers were organized in 1882. This card was produced by H.C. Hill. (Dale Ladd Collection.)

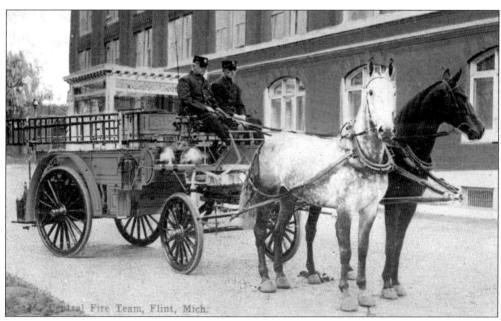

CENTRAL FIRE TEAM. This combination chemical and hose wagon, the first of its character to be bought by the City of Flint, went into commission in October of 1905. It cost $2,270.91. Firefighter Edward H. Price, on the right, became chief on February 15, 1910. The team is on the north side of the Dresden Hotel. In 1905 the fire department was located in City Hall, one block north. (Dale Ladd Collection.)

CRAPO AND BEGOLE. This is a reproduction card showing the two governors of Michigan that lived in Flint. They are Henry Crapo (grandfather of William Durant), governor from 1865–1869, and Josiah W. Begole, governor from 1883–1885. Both are buried in Glenwood Cemetery in Flint. (Bob Florine Collection.)

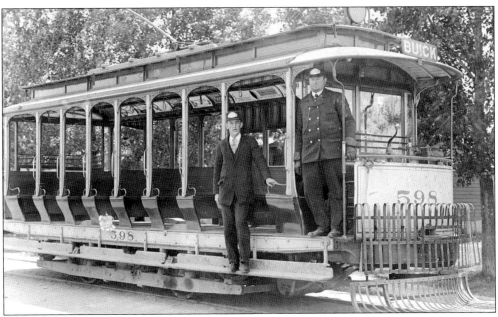

STREETCARS AND INTERURBANS. These vehicles brought a revolution to transportation in 1901. A traveler could simply hop a streetcar to cross town when it might have been necessary to hire a carriage, ride a bike, or walk. Larger interurban cars linked Flint to Detroit and other cities. No. 598 was on the Buick route. (Bob Florine Collection.)

POST OFFICE—FLINT.—Office open during
the business hours of each day except Sundays.
Sundays from 9 to 10 A. M., from 6 to 8 P. M.
MAIL ARRANGEMENTS.—Estern or Detroit
mail arrives between the hours of 6 and 10 P.M
and departs at 5 A.M., every day except Sunday..
The Lapeer mail leaves every Friday at 5 A. M.,
and arrives every Saturday at 2 P. M.
The Shiawassee mail leaves every Monday at 8
A. M., and arrives every Tuesday at 2 P. M.
The Saginaw mail leaves every Monday, Wednes-
day and Friday at 5 A. M., and arrives every
Tuesday, Thursday and Saturday at 7 P. M.
The Flushing mail arrives and departs every Sat-
inday about noon.
ALL MAILS will be closed the evening before de-
parture at 8½ o'clock. W. P. CRANDALL, P.M.

WM. P. CRANDALL, POSTMASTER, 1839, 1840, 1844, 1845

POST OFFICE HOURS. This is a reproduction card and shows specific hours for the Flint Post office *c.* 1840. The office was open during business hours six days a week, one hour Sunday morning, and two hours Sunday evening. The card, which shows the times for the departure and arrival of mail to and from various destinations, was produced by Harry Hill in the 1950s. (Bob Florine Collection.)

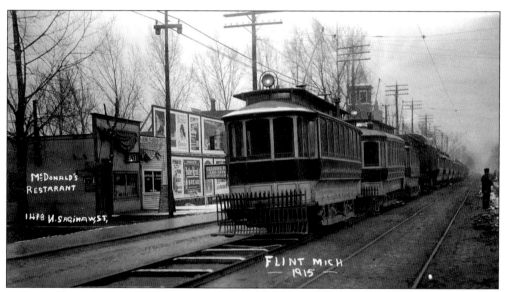

NORTH SAGINAW STREET. This card is dated 1915 and is verified by the McDonald's restaurant and Bowles Bros. Tailor Shop shown on the east side of the street in the block south of Wood Street. The Detroit United Railway (DUR) cars are heading north using temporary tracks while street repairs are being made. The DUR was an interurban railway system connecting Detroit with several southeastern Michigan cities in the early 20th century. (Debbie Propes Collection.)

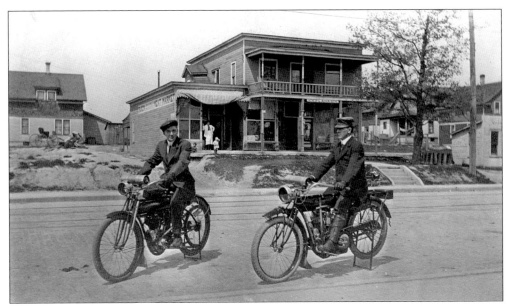

ROBINSON BROTHERS ON THEIR MOTORCYCLES. This picture was taken *c.* 1913–1914 at 2311–2313 North Saginaw Street, outside of the Buick Meat Market and N.W. Flanagin Grocery Store. (Sloan Museum Collection.)

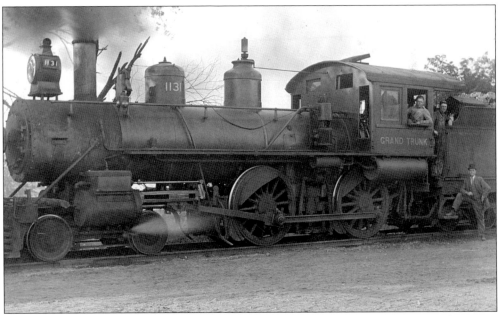

NO. 1131. Steam engines like this one, No. 1131 of the Grand Trunk Railroad, were a common sight in downtown Flint many years ago. The tracks crossing Saginaw Street often created traffic jams on Flint's main street. (Sloan Museum Collection.)

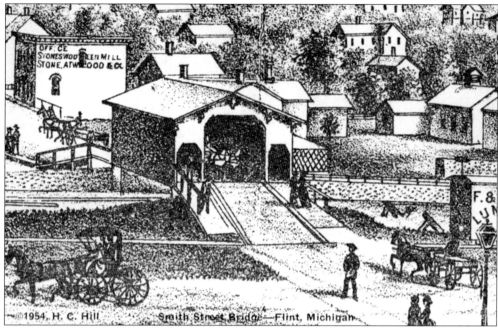

SMITH STREET BRIDGE. In the 1950s, H.C. Hill published a series of postcards based on old photos or drawings from Flint's history; this one shows a wooden covered bridge that once spanned the Flint River at Smith Street, which came from the north side and met Grand Traverse. There was a later truss bridge at Smith Street, then it was replaced by a concrete bridge. The street was renamed in 1958, so that the entire street was named Grand Traverse. (Jack Skaff Collection.)

HOUSE FROM LOG. This log was on display in Flint for two weeks in 1905 after being exhibited at the St. Louis World's Fair. It was owned by Charles Hingle of Flint, and was later displayed in Detroit's Palmer Park. (Dale Ladd Collection.)

MAYOR MCKEIGHAN. This is the only person to be elected mayor of Flint five times, in 1910, 1922, 1927, 1931, and 1932. He was one of the most successful and controversial politicians in Flint history. The *Flint Journal* stated he was "the subject of undying devotion and fanatical hatred." His inauguration as mayor in 1927 was broadcast by radio station WFDF, a first at the time. (Bob Florine Collection.)

WM. H. M'KEIGHAN
Mayor of Flint

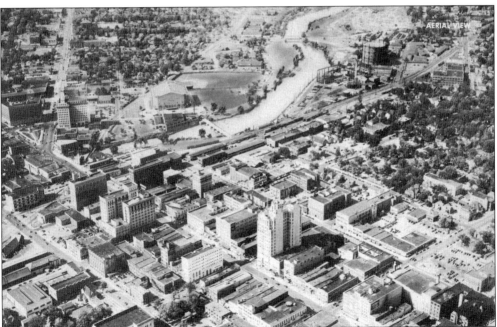

FLINT FROM ABOVE. This aerial view shows downtown as it looked in the late 1930s on a "Jumbo" postcard 7 inches by 9 inches. The IMA auditorium is to the left of center, with Athletic Park behind it, and the former Consumers Power storage tank is at the upper right. (Bob Florine Collection.)

BISHOP AIRPORT. This *c.* 1940 photo shows the first airport terminal, built by the WPA in the 1930s, on 225 acres of property which was donated for an airport by Arthur Giles Bishop in 1928. Airmail service began on November 27, 1940. The first commercial air service began on January 15, 1937 by the Pennsylvania Central Airlines. This building was used by Flint Air Service for private and corporate planes from about 1950 until 1991 when it was demolished for the third terminal. The airport now occupies about 1,700 acres. (Bob Florine Collection.)

BISHOP AIRPORT. The plane has "Capitaliner" on its nose. Pennsylvania Airlines began flying to Bishop in 1936, then was taken over by Capital Airlines. In 1951, Capital began the first regular service to Flint using four-engine planes. In 1960, a struggling Capital Airlines became part of United Airlines. This was the second terminal at Bishop, and was used from about 1950 until 1993, when it was replaced by the one in current use. (Jack Skaff Collection.)